Andy Warhol's

New York City

Four Walks

Uptown to Downtown

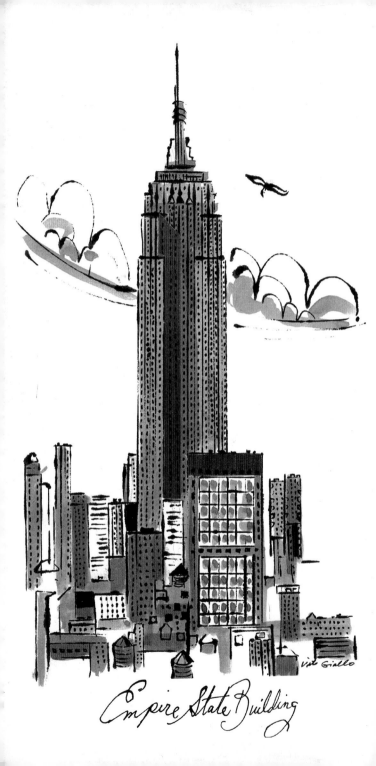

Empire State Building

Andy Warhol's

New York City

Four Walks

Uptown to Downtown

Thomas Kiedrowski

Illustrations by Vito Giallo

The Little Bookroom
New York

© 2011 The Little Bookroom
Text © 2011 Thomas Kiedrowski
Illustrations © 2011 Vito Giallo

Published by The Little Bookroom
435 Hudson Street, Suite 300
New York NY 10014
editorial@littlebookroom.com
www.littlebookroom.com

10 9 8 7 6 5 4 3 2 1

Library of Congress Cataloging-in-Publication Data
Kiedrowski, Thomas.
Andy Warhol's New York City : four walks, uptown to downtown /
by Thomas Kiedrowski.
p. cm.
ISBN 978-1-892145-93-2 (alk. paper)
1. New York (N.Y.)—Guidebooks. 2. Walking—New York (State)—
New York—Guidebooks. 3. Warhol, Andy, 1928–1987. 4. Artists—
Homes and haunts—New York (State)—New York—Guidebooks.
I. Title.
F128.18.K49 2010
917.47′10443—dc22

2010046961

Printed in The United States of America

front cover: David McCabe: Andy Warhol, Edie Sedgwick,
and the Empire State Building from the roof of David McCabe's
studio, 1965. © David McCabe.

back cover: Burt Glinn: Andy Warhol with Edie Sedgwick and
Chuck Wein, New York City, 1965. © Burt Glinn/Magnum Photos.

frontispiece: Vito Giallo: The Empire State Building.
© Vito Giallo. Courtesy of the artist.

Contents

When I first visited New York City

a number of years ago, my friends asked me what I wanted to do. See the spectacular view of Manhattan from the 86th Floor Observatory of the Empire State Building, perhaps, or the brilliance of Times Square lights after a Broadway show? Explore the shops and cafés of Greenwich Village?

Instead, I pulled out a list of addresses that all concerned Andy Warhol's life in the city: the Silver Factory at 231 East 47th Street, the White Factory at 33 Union Square West, his townhouse at 1342 Lexington Avenue and 89th Street. My friends began to ask me what went on in those places. So we set out on a long walk through the Upper East Side to see where Warhol had lived, passing the windows of the Barneys department store. There I was confronted by a giant head of Warhol constructed out of telephones, just another piece of evidence that his story is woven intricately through so many aspects of life in New York City, even almost twenty-five years after his passing.

He lived here for almost four decades, establishing careers as a commercial artist, a major modern painter, an innovative filmmaker, a magazine publisher, a socialite, a music promoter, and a totally unique celebrity figure. He frequented restaurants, stores, theaters, musical venues, and hot spots. He loved New York City from the Empire State Building to Central Park, from old churches to galleries and boutiques. He embraced the city and all of its star power, both the cutting edge and the latest thing, as well as the established and the venerable.

Soon after that initial visit, I moved to the city and continued my quest to locate the sites where Warhol lived, worked, played, and worshipped, leaving his own stamp on many of them in the process. Eventually, I reached out to people who knew Andy Warhol, and began recording histories from the characters of Warhol's New York past, tales of what happened and when.

This book is the result of my research, a collection of stories surrounding certain buildings and locations that have cemented my own connection with Andy Warhol.

I offer the book to the like-minded, for anyone who has wondered where all of those legendary Warhol events actually happened: Where did he live (with his mother), eat, and drink? Where were the four different Factories? Where were his paintings silkscreened and his movies shot? Where did his exhibitions open, in galleries or museums? Where did he present the Velvet Underground, performing with his movies projected over them? Where did he pop up with Edie Sedgwick and his collection of superstars? Where were Studio 54 and Max's Kansas City? Where was he shot?

Of course, many changes in the visual landscape have taken place over the years, victim to Warhol's own predilection: "I like old things torn down and new things put up every minute. I like new buildings going up." But enough is left to allow the interested to walk the streets of New York City and get some sense of Andy Warhol's world and how much of the city's life he enriched. From the beginning, he was star-struck by the city itself, and eventually became one of its biggest stars.

— Thomas Kiedrowski

Editor's Note

Many books have been written about Andy Warhol from the various perspectives of the eras he lived through and embodied, his work in specific genres like film or painting, his biography and life as a public figure. *Andy Warhol's New York City* is unique for its geographical framing, mapping Warhol across the grid of Manhattan. The eighty entries here are loosely organized into four walks.

Some of the locations remain intact and will evoke the era when Warhol roamed Manhattan. In other places, a modern structure on the spot may interfere with the attempt to reconstruct the past. A solid star icon ✳ indicates that the site still exists, more or less in the same form as when Warhol was around. A hollow star icon ☆ indicates that it has been repurposed but still exists. No star indicates the building has been razed.

The order of sites should be adjusted to suit one's interests. Hopefully, the walks here will give you some idea of what it was like to be with Andy Warhol, to see Andy Warhol, or to be touched by all the things that Andy Warhol did.

Andy Warhol moved to Manhattan
in the summer of 1949 after completing his studies
in painting and design at the Carnegie Institute of
Technology (later Carnegie Mellon University) in his
hometown of Pittsburgh. He took to New York City
immediately, exhibiting an indefatigable energy
throughout his four decades here, for discovering
the newest venues for art, fashion, and society, while
maintaining a healthy respect for its oldest institutions.
It is a true sign of his adaptability and breadth that he
is identified with both Uptown and Downtown, with
both the Plaza Hotel and Max's Kansas City, with
Elaine's and La MaMa, with Bloomingdale's and the
Flea Market on Sixth Avenue. *Andy Warhol's New York
City* begins on the Upper East Side and moves, back
and forth in time, across the geography of the city.

1
Truman Capote Residence
Early 1950s
1060 Park Avenue (87th St.)
☆

In 1952, Andy Warhol contacted Truman Capote's agent,
Marion Ives, to obtain the address and telephone num-
ber of the wildly successful young author. Since the
publication in 1948 of Capote's *Other Voices, Other Rooms*,
with a seductive photo of Capote on the back cover,
Warhol had dreamed of a personal connection to him.

With the address in hand, he began to hang
around this Park Avenue building in hopes of running
into Capote in person, as he would later do with other
people he admired; he waited on Julie Andrews for
hours at the stage door of the Mark Hellinger Theatre
when she appeared in *My Fair Lady* in 1956. Warhol
sent Capote postcards and telephoned frequently, ini-
tially becoming friendly with his mother, Nina. The
two went out on tea dates before spending an after-
noon at the Blarney Stone, then on Third Avenue;

Warhol soon realized she was just looking for a drinking companion.

Warhol thought Capote would befriend him if he appeared successful himself, so he found a gallery to show his work and invited Capote and his mother to the opening. On June 16, 1952, the Hugo Gallery (26 East 55th Street, razed) displayed Warhol's *15 Drawings Based on the Writings of Truman Capote*, along with sculptures and drawings by Irving Sherman. Capote and his mother didn't make the opening but did manage to see the show before it closed. It would be years later, after Warhol's own celebrity had been established, that he and Capote became friends.

2
Andy Warhol Residence
1960–1974
1342 Lexington Avenue (89th St.)

In September 1960, Warhol purchased his first building, an elegant 1889 Northern Renaissance Revival rowhouse. He moved himself, his mother Julia Warhola, and their cats from Murray Hill to this residence in Carnegie Hill. Located in the unique Hardenbergh/ Rhinelander Historic District (*see page 17*), the house had belonged to a psychiatrist and was one street away from where he had first sought out Truman Capote. Warhol must have imagined himself moving easily into a more elite crowd from this location. His new space provided room to create and entertain and, just as important, room to store his many purchases. He quickly began to fill up the brownstone with antiques, artwork, and eclectic junk from every corner of Manhattan.

Warhol had already made a name for himself as a commercial illustrator but craved recognition as an artist, telling fellow Carnegie Tech graduate Gillian Jagger he longed to be famous. She remembers him in the early fifties producing brilliant work but always

1342 Lexington Ave.

trying a little too hard to please as he concocted schemes to get recognized. By the late fifties, although he had had several shows during the previous years, his drawings of boys, shoes, and cherubs had hardly brought him the celebrity status he sought.

Soon, he found new inspiration. With the help of a light projector, Warhol traced and painted enlarged cartoon scenes from the Sunday comics onto canvas. When he discovered that an artist named Roy Lichtenstein had been using similar images, he turned to more banal subjects such as dollar bills and postage stamps.

Warhol moved on to photo silkscreens. Most earlier works had been hand-painted or inked with stamped impressions from carved gum erasers. "I started when I was printing money. I had to draw it, and it came out looking too much like a drawing, so I thought wouldn't it be a great idea to have it printed. Somebody said you could just put it on silkscreens. So when I went down to the silkscreener I just found out that you could reproduce photographs." Early photo silkscreens included a baseball player (Roger Maris) who had just struck a ball and celebrities Tab Hunter, Natalie Wood, and Troy Donahue.

One day Nathan Gluck, Warhol's assistant, called up former assistant Vito Giallo and said, "You'll never guess what Andy's working on." Vito Giallo couldn't believe it when Nathan announced, "Campbell's soup cans." Warhol took the most common product in the supermarket and gave it new life by simply drawing people's attention to it, as he also did with Coca-Cola bottles.

When Marilyn Monroe died in 1962, he began to paint portraits of her using a publicity shot from the film *Niagara*. Images of Liz Taylor and many others followed.

Warhol let the door slowly close on commercial assignments while his efforts went into being a full-time artist. In the summer of 1962, Eleanor Ward offered him a November exhibit at the Stable Gallery. The show's overwhelmingly positive reception encour-

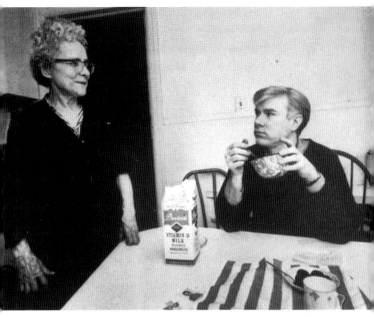

Ken Heyman: Andy Warhol and his mother Julia. © Ken Heyman/Woodfin Camp/ Time Life Pictures/Getty Images.

aged Warhol to produce new work. It had become increasingly difficult to work on paintings among the growing collection of furniture and antiques in his house. The process of setting up an area, squeegeeing paint onto canvas, and cleaning the screens became a chore in the cramped quarters. He decided to look for a painting studio and found a nearby firehouse with a second floor ideal for screening large canvases.

Simultaneously, Warhol began to take a serious interest in experimental film. He attended many screenings at Jonas Mekas's Film-makers' Cinematheque in the early sixties and was soon ready to make his own mark in filmmaking. In 1962, it was noted in *American Girl* magazine (the Girl Scout organ, no less) in a sidebar accompanying a Warhol illustration, that he was making an "experimental movie."

Warhol had long dabbled in film. At home in Pittsburgh, he had a film projector when he was young;

he later worked on a film assignment with other art students at Carnegie Tech in the forties. He and his friend Charles Lisanby traveled around the world in 1956 with an 8mm camera. In 1963, Charles Henri Ford and Gerard Malanga accompanied him to Peerless Camera, directly across from Grand Central, where he purchased a 16mm Bolex and began filming single 100-foot reels.

In January 1964, the newspapers covered the confusion and outrage of viewers who saw his first epic film, *Sleep*. He would go on to film an extraordinary amount of footage, and would gain international acclaim yet again, as a filmmaker. The early film projects spliced together in this home have become legendary.

In 1968, Warhol was shot and nearly killed. After being released from the hospital at the end of July, he recuperated slowly in this house. His mother and his live-in boyfriend, Jed Johnson, cared for him until he felt well enough to once again make public appearances, as he did at a party in his honor in late October 1968. A group of close friends and artists attended a pig roast in a courtyard at 5 Ninth Avenue (now the restaurant 5 Ninth) near Little West 12th Street; a few took it upon themselves to stomp grapes with their bare feet in large containers à la Lucy Ricardo from *I Love Lucy*.

With Julia Warhola's departure for Pittsburgh in the fall of 1971 and her subsequent death in 1972, along with the fact that there was no more room in the brownstone due to his buying habits, Warhol relocated to a new residence. Not unlike Pablo Picasso, who was known to fill up a home with his many art works and belongings and simply move on to another location, Warhol moved in 1974 to a larger townhouse in a more fashionable area of the Upper East Side of New York on East 66th Street and rented his former house to his longtime business associate, Frederick Hughes, who bought this property in 1988 from the Warhol estate. The house has since changed hands several times.

The Hardenbergh/Rhinelander Historic District

is comprised of seven buildings located at the northwest corner of Lexington Avenue and East 89th Street. Built in 1888–89, six are rowhouses and the seventh a "French Flats" building. All were designed in the Northern Renaissance Revival style by architect Henry J. Hardenbergh for the Rhinelander family, whose Rhinelander Real Estate Co. owned the properties until 1948. The terra cotta, red brick, and brownstone façades of the six rowhouses create a pleasing sightline, with varied window treatments and a roofline of parapets, cornices, and differentiated pediments. The flats building sits behind the houses, facing 89th Street, and is constructed with the same materials and colors. The continuity of ownership of this group of buildings for over six decades, with their common design scheme intact, has left an unusually cohesive remnant of an age of uptown development—made possible by improved streets and municipal transportation.

3
St. Thomas More
1960s
65 East 89th Street (Fifth Ave./Madison Ave.)
✳

When they moved to their uptown residence on Lexington at 89th Street, Julia Warhola and her son attended church at St. Thomas More, up the street from their new home and close to Central Park. The actress Sally Kirkland recalled seeing Warhol and his mother visiting church here often, in close proximity to Kirkland's parents' apartment at 17 East 89th Street, where Warhol would visit in 1964. In 1965, Sally Kirkland, Sr., the fashion editor for *Life* magazine, hosted a party at her apartment where Warhol's *13 Most Beautiful Women*, a collection of female screen tests, was projected; later she would use Warhol's films in a fashion spread for

Life. Warhol and his mother would go on attending services at St. Thomas More until her failing health prompted her to move back to Pittsburgh in 1971.

4
Hook & Ladder 13
(Warhol's Firehouse Studio)
1963
159 East 87th Street (near Lexington Ave.)
✷

Nestled just east of Lexington Avenue on 87th Street, this former firehouse was shuttered in 1915 when a more suitable building on 85th Street became available for Hook and Ladder Co. 13. Warhol wrote the city real estate department with an offer and signed a lease on December 21, 1962, for $150 a month rent for the space. It was ideal for creating large canvases, although it had no hot water, and running water only from a sink in the back. He hired a college student named Gerard Malanga to help with the stretching and screening of canvases.

Little had been done to the building for ages. The roof leaked, ruining a handful of paintings, but Warhol continued creating what was later called his *Death and Disaster* series. *Tuna Fish Disasters*, *Car Crashes*, *Electric Chair* paintings, and *Birmingham Race Riots* also originated from this location. When JFK was assassinated later in the year, Warhol promptly initiated a *Jackie* series. (He would return to the Kennedy family as a subject with the *Flash—November 22, 1963* series in 1968 and a silkscreen portrait for Ted Kennedy's 1980 presidential campaign.) In addition, he screened a large number of life-sized silver *Elvis* paintings here for a second show at the Ferus Gallery in Los Angeles, a followup to his *Campbell's Soup Cans*. In 1963, the old firehouse was sold by the city, and Warhol signed a lease for the Factory loft on 47th Street with the help of his friend Henry Geldzahler. The firehouse soon

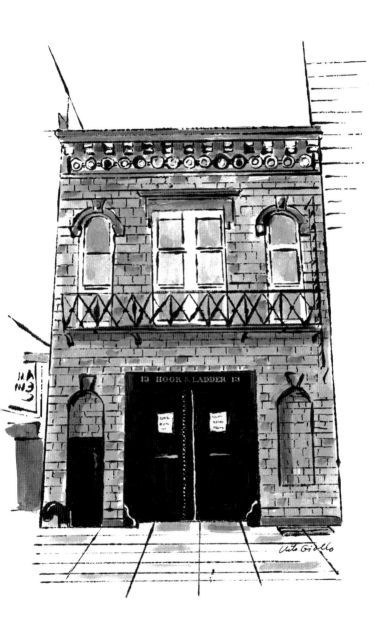

159 E. 87ᵗʰ St. Firehouse Studio

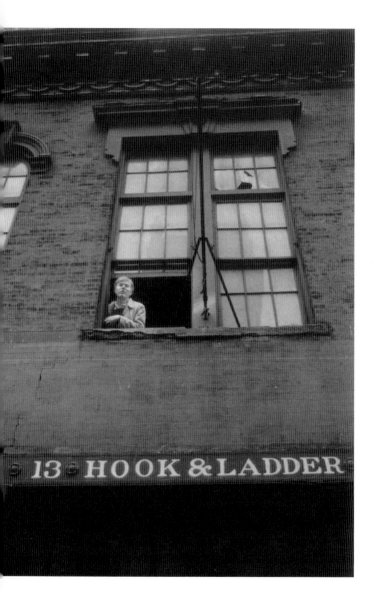

Edward Wallowitch: Andy Warhol looking out the window of the studio, above, and at right, at work inside the firehouse studio, circa 1963, reprinted with permission from Paul Wallowitch © 2011.

housed the Daniel Wildenstein Gallery, a forerunner of PaceWildenstein.

The façade of the firehouse hasn't changed much since it first opened in 1865; at the time of publication, the letters still spell out "13 Hook and Ladder 13."

5
John Giorno Residence—RAZED
Early 1960s
255 East 74th Street (Second Ave./Third Ave.)
At this address in 1963, Warhol attentively watched the sleeping habits of his close friend and lover, John Giorno, through the lens of his 16mm Bolex. Throughout the summer months, Warhol captured Giorno's breathing, his movements, and his slumber with the recently purchased camera. In September, the filmmaker and critic Jonas Mekas announced Warhol's plans in *The Village Voice* for a film study of a sleeping man. An eight-hour work was publicized, but when *Sleep* debuted on Friday, January 17, 1964, at the Gramercy

Arts Theatre, the film lasted *only* five hours and twenty minutes. The audience came and went as they pleased. Few people actually remained for the duration. To this day, John Giorno still holds onto the mattress partially seen in Warhol's film.

6
Frank E. Campbell Funeral Chapel
1969 for Judy Garland's funeral
1076 Madison Avenue (81st St.)
✶

In operation for over a century, this funeral home has hosted services that created media sensations of biblical proportions starting with Rudolph Valentino's memorial in August 1926. Services for Jacqueline Kennedy Onassis, Greta Garbo, Irving Berlin, John Lennon, William Randolph Hearst, Ed Sullivan, Jim Henson, Frederick Hughes, and Diane Arbus were all held here. In 1969, the superstar Candy Darling (a.k.a. James Slattery) and the Silver Factory regular Ondine (a.k.a. Robert Olivo) accompanied Andy Warhol to Frank Campbell's to catch a glimpse of the deceased Judy Garland. As they waited for hours in line, Warhol recorded the experience with his tape recorder. Later, Candy Darling's funeral would be held here after she died of cancer before the age of thirty. Warhol was not among the many celebrities who attended Candy's wake.

7
The Episcopal Church of the Heavenly Rest
1960s, 1970s, 1980s
2 East 90th Street (Fifth Ave.)
✶

This neo-Gothic church, with Art Deco detailing, was completed at the time of the Great Depression. Mr. and Mrs. Andrew Carnegie, who maintained a residence across the street, provided the land for the building.

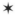

Andy Warhol often attended services here later in his life and volunteered in the church's soup kitchen on major holidays, usually accompanied by members of his staff. It seems likely that he and his mother would have strolled here often when they lived a few blocks away.

Gloria Swanson's ashes are interned here in a basement mausoleum.

8
Jewish Museum
1960s, 1970s, 1980s
1109 Fifth Avenue (92nd St.)
✷

The Jewish Museum has a rich history of displaying and celebrating, for more than a century, works by artists who have explored and contributed to Jewish culture. Founded in 1904, the museum has occupied the elegant French Gothic Warburg mansion since 1947, sitting like a jewel in the crown of Manhattan's Museum Mile. The collection has grown to over 26,000 pieces and counting.

Warhol's work first appeared at the Jewish Museum in *The Board of Governors Collects* in April 1965; the show included items ranging from a Third Millennium, BC, stone head to one of Warhol's *Flower* paintings. In 1968, Jonas Mekas, who began the Film-maker's Cinematheque, became the film curator for the Jewish Museum. During his three-year stay, he screened films by contemporary filmmakers, including Warhol in November 1969 with *Bufferin* starring Gerard Malanga and *Eat* starring Robert Indiana (who the museum had commissioned in 1967 to create a work celebrating Purim).

In 2008, *Warhol's Jews: Ten Portraits Reconsidered* reprised his show from twenty-eight years earlier: *Ten Portraits of Jews of the Twentieth Century*. A concurrent show of contemporary artists called *Art, Image and Warhol Connections* included Deborah Kass, like Warhol

a graduate of the Carnegie painting program. Kass's *Warhol Project* superimposed images of important Jewish figures, or her own image, onto Warhol's iconic portraits of Elvis, Jackie, Liz, and others, with uncanny results.

9
Solomon R. Guggenheim Museum
1963
1071 Fifth Avenue (89th St.)
✴

Warhol first exhibited work at the Guggenheim in 1963 as part of a show titled *Six Painters and the Object*. For the 50-cent entry fee, visitors could see work by Warhol, Jim Dine, Jasper Johns, Roy Lichtenstein, Robert Rauschenberg, and James Rosenquist. The museum houses an impressive permanent collection including Warhol self-portraits, a multicolored *Marilyn*, and a *Disaster* painting from his firehouse studio days.

10
The Metropolitan Museum of Art
1950s, 1960s, 1970s, 1980s
Fifth Avenue (80th St.–84th St.)
✴

One can easily get lost for an afternoon within this mammoth structure occupying over two million square feet, with works spanning several millennia, and countless artists, ages of art, and cultures. The *Mona Lisa*'s visit to the Met in 1963 inspired many artists to paint her image, including Warhol, who did a series of silkscreens of Leonardo's masterpiece. Among the museum's many early Warhol works, one can find brightly colored paintings of Warhol's three muses: Marilyn, Liz, and Jackie.

A rare sixties dress with a colorful pretzel print can also be found in the permanent collection of the

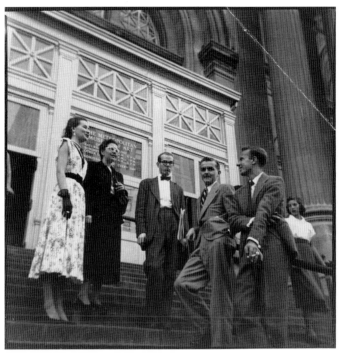

Leila Davies Singelis: *At the Met,* 1953. (Andy Warhol at center with bow tie.) Collection of The Andy Warhol Museum, Pittsburgh. © Leila Davies Singelis. Courtesy of the artist.

Costume Institute. Warhol designed this dress for Serendipity 3, the restaurant where he hung and sold his work in the fifties. One of the founders, designer Stephen Bruce, claims the dress and a robe decorated with ice cream cones were the first pieces of clothing with Warhol designs.

The grand steps that lead to the entrance of the Met have provided an illustrious background for photographers' images—e.g., Warhol caught in the arms of Edie Sedgwick wearing a lilac jumpsuit. He also made the acquaintance here of Paulette Goddard at the Met's *Art's Gold Show* in 1973 before squiring her all around town.

11
Coe Kerr Gallery
1976, 1977
49 East 82nd Street (Madison Ave./Park Ave.)
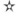

Andy Warhol and Jamie Wyeth exhibited *Portraits of Each Other* at this gallery in 1976. The next year, art collector Richard Weisman's commissioned portraits of *Warhol's Athletes* were displayed here, including images of O. J. Simpson, Muhammad Ali, and Pelé. Some of these original paintings were reported stolen out of Weisman's California home in 2009.

12
Bianchini Gallery
1960s
16 East 78th Street (Fifth Ave./Madison Ave.)
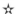

The American Supermarket was the name of an October 1964 exhibit celebrating consumerism, in which gallery patrons pushed shopping carts through aisles of grocery-related objects of art, while listening to canned grocery-store music and snacking on free blintzes. Warhol's works featured prominently in the show, including Brillo boxes, signed cans of Campbell's soup, and paper grocery bags silkscreened with the familiar soup-can image. *Life* magazine covered the event in a two-page color spread. Though the gallery at this address has long since departed, a re-creation of the exhibit was staged at the Andy Warhol Museum in Pittsburgh in 2003 using some of the original pieces.

13

Leo Castelli Gallery

1960s–1980s

4 East 77th Street (Fifth Ave./Madison Ave.)

☆

In 1964, Leo Castelli asked Andy Warhol to join his
impressive lineup of contemporary artists, which
included Roy Lichtenstein, Jasper Johns, Robert
Rauschenberg, Frank Stella, and Donald Judd. This
stately building once held the Leo Castelli Gallery and
several Warhol shows were presented here during the
artist's career. His *Cow Wallpaper*, *Floating Silver Cloud
Balloons*, and Day-Glo® *Flower Paintings* were all on
display at this location. Other Castelli Warhol shows
in New York included *Maos*, *Dollar Signs*, and a variety
of other well-known paintings.

　　In November 1966, photographer Patricia
Caulfield, whose images of hibiscus blossoms were
appropriated by Warhol for his *Flower Paintings*, filed a
lawsuit against Warhol for using her image without
permission. Warhol ended up paying Caulfield in paint-
ings and a percentage of all future sales of prints of
the *Flower* works.

14

Whitney Museum of American Art

1960s, 1970s, 1980s

945 Madison Avenue (75th St.)

✳

Home to an extensive collection of twentieth-century
American art, the museum, founded in 1931 by
Gertrude Whitney, has found innovative ways to expand
its holdings and increase its standing in the art world,
particularly since moving into this Madison Avenue
landmark in 1966. Warhol attended the opening in
a black leather jacket and bow tie, and would return
here many times. In 1971, the Whitney hosted an early
Warhol retrospective, and in 1979, presented *Portraits*

of the Seventies, an ensemble of fifty-six pairs of
Warhol's most dazzling portrait paintings, and a major
milestone in his career. Paulette Goddard accompanied
him to the opening.

Since the eighties, the Whitney has collaborated
with the Museum of Modern Art to help preserve hun-
dreds of early Warhol films. The Whitney's Andy Warhol
Film Project has made his films available to a new
generation of Warhol fans.

15
Vito Giallo Antiques
1970s–1980s
966 Madison Avenue (76th St.)
☆

Vito Giallo, the artist who served as Warhol's first
paid assistant in 1955, later opened a succession of
antique stores that drew in the rich and famous. From
1980 until his death, Warhol made Giallo's Madison
Avenue shop a number-one priority. He would stop
by or telephone on a daily basis to inquire about
new items, and to find out any new gossip involving
Giallo's many celebrity customers: who was shopping,
what they bought, what they were wearing.

Early on, Giallo noticed that Warhol was drawn
to multiples, preferring to buy items in sets. Whether
it was a stack of art books or a collection of pottery,
Warhol preferred to purchase groups of things; and if
he paid in cash, the money was usually fished out of
his shoe. A few days before his death, Warhol bought
an Indian rug, and Giallo still has the receipt for the
balance due.

Giallo sold thousands of items to Warhol, and
much of the Sotheby's catalogue of Warhol's estate
details purchases from Giallo's store. Many of the recov-
ered items from Warhol's townhouse, most of which
were found in bags, were still packaged in Giallo's
original wrappings. A ten-day auction of Warhol's

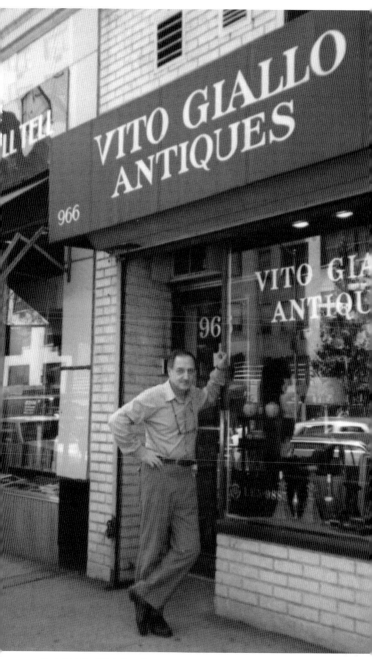

Starla Smith: Vito Giallo in front of his antique shop at 966 Madison Avenue, 1989. Photo © and courtesy of Starla Smith.

estate in 1988 brought in $25 million, $10 million more than expected.

Vito Giallo has retired from the antique business but continues his career as an exhibiting artist.

16
Andy Warhol Residence—RAZED
1952–1953
216 East 75th Street (Second Ave./Third Ave.)
Through a friend, Warhol subleased an apartment at 216 East 75th Street in 1952, where he first lived with his mother in the city. From here, he began to write notes to Truman Capote.

17
Stable Gallery
1962 and 1964
33 East 74th Street (near Madison Ave.)
☆

In November 1962, Eleanor Ward, owner of the Stable Gallery, offered Warhol a show. With much fanfare, his first solo *New York Pop Art* show turned Warhol into a media marvel. The paintings of Coca-Cola bottles and Campbell's soup cans, the images of Marilyn Monroe and Elvis, were revered not only for their brilliant color but for the cultural values they reflected and refracted. Two years later, the gallery would also host Warhol's *Brillo Boxes* and other sculptural boxes derived from supermarket items, but to a much different response. The press turned on Warhol for the banality of the work and it was rumored that several high-profile collectors canceled their pre-show orders. The unsold boxes were wrapped and stacked up on the third floor of his Lexington Avenue townhouse.

Warhol left Ward's stable of artists for the Castelli Gallery, and the Whitney Museum eventually took over this property. The night of Ward's death, she visited Vito Giallo Antiques with her longtime assistant Alan

Fred W. McDarrah: Andy Warhol with his Brillo box sculptures in the Stable Gallery, April 21, 1964. Photo © Fred W. McDarrah/Getty Images. © 2011 The Andy Warhol Foundation for the Visual Arts, Inc./ Artists Rights Society (ARS), New York.

Groh, directly after a minor operation at Lenox Hill Hospital. With encouragement from a doctor, she decided that she was going to get into better shape and start exercising. Knowing Warhol worked out with a trainer regularly, she stopped in to ask Giallo for Warhol's number; she told Giallo she would call Andy the second she got home. The next day, Alan Groh was notified of Ward's death by her maid. When he arrived at her home, he found her seated upright, still clutching the phone in her hand. Giallo later asked Warhol if Ward had gotten in touch with him; Warhol was unaware that she had tried to reach him.

Eleanor Ward is credited with one major gallery innovation: painting her gallery walls a dark gray, to make the artwork pop, instead of the traditional stark white.

18
Andy-Mat
1977
933 Madison Avenue (74th St.)
☆

The first link in a proposed international chain of Andy Warhol fast-food restaurants would have opened at this location in 1977. The concept of the Andy-Mat, a clever take on the Automat, had Warhol and British entrepreneur Geoffrey Leeds in talks since 1974. Both men had enjoyed dining at Schrafft's years earlier and had yearned for the type of comfort food they had as kids. Leeds said the Andy-Mat would be "a neighbor-hood restaurant with a varied menu, simple good food, reasonable prices, a place where you don't have to be embarrassed to take someone—one was never embar-rassed to take someone to Schrafft's."

During the Silver Factory days, Warhol and his entourage could often be found at Schrafft's, located at 556 Fifth Avenue and 47th Street, and Warhol was asked to do a commercial for Schrafft's in

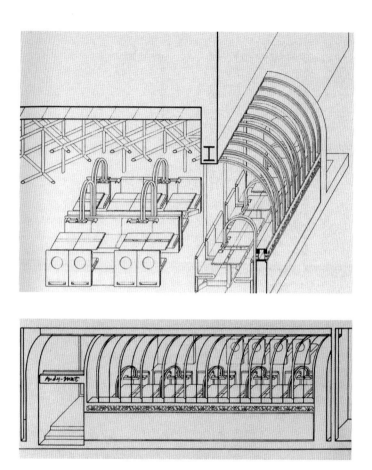

Architectural drawings of the proposed Andy-Mat. © Cossutta & Associates, Architects.
Courtesy of the architect.

1968. The 60-second spot shows an image of a red dot, then slowly zooms out to reveal a maraschino cherry and then a melting chocolate ice cream sundae. At the end, a credit line rolls diagonally, "The chocolate sundae was photographed for Schrafft's by Andy Warhol."

Warhol asked close friend and society hostess Maxine de la Falaise McKendry (she appeared in Warhol's *Dracula*) to prepare the menu for the 115-seat Andy-Mat, which she did with guidance from Tony Berns of the restaurant 21. She often cooked for Warhol's Factory regulars and at one time was a food columnist for *Vogue*. The seventy-five items were to be priced between $1 and $5.75 and included shepherd's pie, fishcakes, Irish lamb stew, fried onion tart, mashed potatoes, key lime pie, champagne fruit drinks, milk over ice, and a choice among four omelets (Warhol's diet regimen at the time). Said Andy: "I really like to eat alone. I want to start a chain of restaurants for other people who are like me called Andy-Mats—'The Restaurant for the Lonely Person.' You get your food and then you take your tray into a booth and watch television."

The orders were to be placed directly by the customer to the kitchen via a system of pneumatic tubes, for there would be no in-house chef. All food was to be prepared off-site, frozen, and delivered to the franchise to be reheated. The original concept was for a "sit-down supermarket" and came together with the help of Bob Peltz, the king of frozen food at that time. The architectural team of Araldo Cossutta and Vincent Ponte drew up blueprints to turn a former Gristedes supermarket into a semi-classy fast-food haven utilizing simple geometric shapes. Ellen Lehman McCloskey designed the interior, turning up the heat in the dining area with red mohair velvet banquettes. The venture never opened due to concerns over whether they had the proper location; appropriately, but perhaps not

strategically, the Andy-Mat would have been practically next door to the site of Warhol's first New York Pop Art show at the Stable Gallery. The investors had already spent $40,000 in rent and secured a million in capitalization when the project fell apart.

19
The Gymnasium
1967
420 East 71st Street (First Ave./York Ave.)
☆

New York's Sokol Hall sailed through its centennial shortly before the end of the twentieth century, having housed Sokol New York the activity center serving the Czech and Slovak community since its construction in 1896. The center is known for its gymnastics program

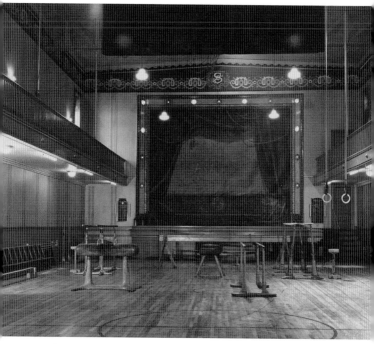

Josef Zaklasnik: The Gymnasium at Sokol Hall. Photo © Josef Zaklasnik. Courtesy of Sokol New York Library.

and has hosted a variety of events over many years from New Year's Eve dances to operatic performances. Beginning January 8, 1967, the New York Obedience Training Club held a ten-week course here for dogs. When the classes ended, the next act took the stage.

Starting March 24, Warhol presented The Velvet Underground here every weekend for just over a month; the promo read "Work Out at the Gymnasium," describing it as "a new happening discotheque." They appeared without Nico, who was out of the band by this time. One of the opening acts included Chris Stein, who would later form Blondie. It was difficult to fill the 50-foot-wide, 115-foot-deep Great Hall and very few bands tried, considering that the gymnastic equipment would remain in place during performances.

20
Andy Warhol Residence—RAZED
1950–1951
74 West 103rd Street (Manhattan Ave.)
A large basement sublet here, acquired illegally through the superintendent, was an early residence for Warhol shortly after relocating from Pittsburgh. Sheila Cole, writer and Warhol apartment-mate, recalls a communal living situation where residents lived chiefly on spaghetti dinners and pooled their pennies on laundry days. Those who worked nights were able to use the beds and sofas of the folks who worked during the day and vice versa. Cole saw Warhol as an extremely diligent worker; he used a small room just off the kitchen, a walk-in pantry, to set up his own studio space. Sheila remembers often getting up early in the morning and realizing that Warhol had been up all night drawing.

Warhol was an early platonic friend to Cole; they talked often, sometimes for hours, sharing stories, problems, and lots of gossip. He asked her to move in the day they met in 1950, then helped her retrieve her belongings from the YWCA (located at 607 Hudson

Street). Cole had felt a kinship with some of Warhol's shoe drawings she'd seen in a women's magazine and, two days after moving to the city, found his name in the New York phone directory. He was listed at this address in November 1950 with the profession of artist.

WALK 2 Upper East Side
East 57th Street to East 68th Street

21
New York Hospital
1987 death
525 East 68th Street (York Ave.)

For Andy Warhol, hospitals meant uncertainty rather than recovery. His *Death and Disaster* series used images from the daily newspapers—tragic lifeless bodies, car crashes, or operations that ended in misfortune. Warhol had avoided having surgery for many years, but when the pain became too great, he agreed to have his gall bladder removed. He checked into this hospital, the operation was performed, and he spent the next afternoon watching television and recovering. However, by early the following morning, February 22, 1987, Warhol's health had deteriorated. He was pronounced dead at 6:31 AM.

22
Paraphernalia
mid-1960s
795 Madison Avenue (67th St.)

In 1965, Andy Warhol and members of his entourage were asked to create a "happening" for the opening of Paul Young's ultra-hip fashion boutique. Paraphernalia featured many New York designers, including Betsey Johnson, alongside British imports. The atmosphere was relaxed: one could sit and flip through a magazine while watching TV or listen to the latest pop song while smoking a joint. The store remained open until around 2 AM, so customers could buy something before hitting the town.

Warhol filmed scenes here in 1966 for a film short titled . . . *Paraphernalia*.

Paul Young later became executor of Edie Sedgwick's estate.

23
Andy Warhol Residence
1974–1987
57 East 66th Street (Madison Ave./Park Ave.)
☆

Completed April 30, 1902, this five-story brick building
became home to Andy Warhol, his boyfriend Jed
Johnson, their dachshunds Archie and later Amos,
and longtime maids, sisters Aurora and Nena Bugarin.
The brownstone became a depository for cookie jars,
Navajo rugs, pottery, Empire furniture, and Art Deco
jewelry, as displayed in the 1989 Sotheby's auction
catalogs following Warhol's death. This prime address
would be key for Warhol's social life; he was centrally
located to hear all the latest gossip.

He shared his street with C. Z. Guest, Jamie
Wyeth, and later, Imelda Marcos. Warhol could take a
cab up to socialite Alice Mason's for dinner, walk over
to Halston's for drinks, or pop in to visit Phyllis Cerf,
whose husband Bennett had published Truman Capote's
novels and *Andy Warhol's Index Book* (1967) at Random

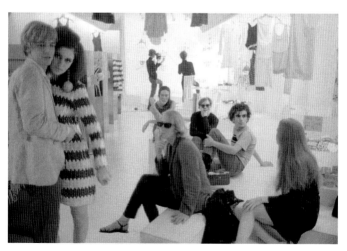

Stephen Shore: Rene Ricard, Susan Bottomly, Eric Emerson, Mary Woronov, Andy Warhol,
Ronnie Cutrone, Paul Morrissey, Pepper Davis at Paraphernalia's opening and show. 1965–1967.
Courtesy of the photographer and 303 Gallery, New York.

57 East 66th St.

Misha Erwitt: Inside Andy Warhol's townhouse at 57 East 66th Street. © Misha Erwitt/NY Daily News Archive via Getty Images.

House. Warhol admired Phyllis as a former Hollywood actress and cousin of Ginger Rogers.

Warhol was also close to his parish and would stop in a few times per week at St. Vincent Ferrer, one and a half blocks away. Warhol lived at this residence until his passing in 1987.

24
The Church of St. Vincent Ferrer
1974–1987
152 East 66th Street (Lexington Ave.)

From the time he was a child, Warhol attended church regularly. "I just sneak in at funny hours," he said. When asked if he believed in God: "I guess I do. I like church. It's empty when I go. I walk around. There are so many beautiful Catholic churches in New York. I used to go to some Episcopal churches too." After his mother's death and his move to 66th Street, he became a steadfast participant at this church for the

remaining thirteen years of his life. He was not known to go to communion or confession, but stopped in a few times each week to pray.

This majestic building is nearly one hundred years old; however, the Catholic parish, founded by the Dominican order, has held mass at this location since 1867. The Gothic Revival church was designed by Bertram Goodhue and features carvings by Lee Lawrie, the sculptor of *Atlas* at Rockefeller Plaza. St. Vincent Ferrer is well-known for society weddings, celebrity funerals, and the fact that Jackie Kennedy once prayed here.

25
Central Park
1950s, 1960s, 1970s, 1980s
East side entrance below 67th Street on Fifth Avenue

✴

Warhol and his boyfriend, Jon Gould, would walk to Central Park on weekends in the early eighties, with a specific destination in mind: the statue of Balto, a black and white Alaskan malamute immortalized in bronze for leading a team of courageous dogs over treacherous terrain through a blizzard to deliver a sled of serum to the diphtheria-stricken town of Nome, Alaska.

Warhol was an animal lover early on. His family dog Lucy was a treasured companion in Pittsburgh. From the fifties through the seventies, he had dozens of Siamese cats in succession all named Hester or Sam. In 1972, then-boyfriend Jed Johnson and Warhol purchased their first dachshund, Archie, who Warhol brought with him everywhere. When confronted by the press, Warhol would often avoid answering and defer any questions to Archie.

Though Jon Gould moved in with Warhol on 66th Street, he had his own residence in Los Angeles, where he worked for Paramount. He left Warhol in 1985 without having acknowledged to his friends the fact that he

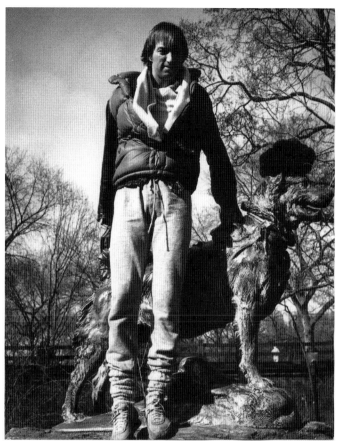

had AIDS, and would pass away at the age of thirty-three in 1986.

The 1925 Balto statue can be found by entering Central Park at the east side entrance just below 67th Street and heading due west, or by heading north-west from the Tisch Children's Zoo. A 1995 animated movie based on Balto's adventures taught children his heroic story, but the statue is a favorite of kids and adults alike.

26
Roy "Halston" Frowick Residence
1970s–1980s
101 East 63rd Street (Park Ave./Lexington Ave.)
☆

Halston, who topped off Jackie Kennedy's 1964 Inaugural ensemble with a pillbox hat, became a world-renowned designer during the 1970s. He and Andy Warhol both came from less than modest backgrounds and shared a love of fame and moments spent in the spotlight. Andy became a regular guest at Halston's, along with Liza Minnelli and Bianca Jagger—most often before heading off to Studio 54 in a chauffeured limousine.

Originally an 1881 stable garage, Halston's house is considered one of the most important examples of post-modern residential architecture on the Upper East Side. It was redesigned by Paul Rudolph and completed in 1968, with raw steel beams and dark brown glass transforming the façade, before Halston purchased it in 1974.

The architect described his redesign of the three-story hideaway: "A world of its own, inward looking and secretive, is created in a relatively small volume of space in the middle of New York City. Varying intensities of light are juxtaposed and related to structures within structures. Simple materials (plaster, paint) are used, but the feeling is of great luxuriousness because of the space. The one exposed façade reveals the interior arrangement of volumes by offsetting each floor and room in plan and section."

27
Edie Sedgwick Residence
1965–1966
16 East 63rd Street (Fifth Ave./Madison Ave.)
☆

By 1965, Edie Sedgwick had moved into a three-and-a-half-room apartment at this address on 63rd Street. The space paled in comparison with her former resi-

dence in her grandmother's legendary multi-room suite at 720 Park Avenue, but Edie had her eyes set on a much bigger arena: New York's social scene. With a personal chauffeur on hand, she attended fashionable clubs and frequented upscale restaurants.

When Edie met Warhol at a party, she could not have imagined the way her life would change. The couple would be inseparable for most of 1965 and were photographed everywhere together. Warhol recognized Edie's beauty, her charisma, and the way she burned right through her inheritance. He cast her in starring roles in several of his films. *Poor Little Rich Girl* and *Beauty #2*, filmed at this apartment, were shown publicly at the Astor Place Playhouse in the summer of 1965.

By the fall of 1966, Edie had become a victim of drugs and was prone to fall asleep suddenly. Her apartment caught fire in the early hours of October 18th—probably due to a cigarette—and luckily, she was pulled from the window by firemen. An image of Edie wearing a leopard-print leotard was captured on camera and printed the following day in the *Daily News*.

In 1971, Sedgwick had married and was living in California, trying to get her life in order after several years of drug abuse. She passed away from an accidental overdose at the age of twenty-eight.

28
The Gilded Lily/A La Carte/ Kaleidoscope
1950s–early 1960s
21 East 63rd Street (Fifth Ave./Madison Ave.)

This former Bloomingdale mansion became home to Joan "Tiger" Morse's stylish vision of fashion. Originally, she had sold jewelry and elegant hand-stitched dresses to a wealthy Upper East Side clientele from her shop at 780 Madison Avenue. This building was divided into separate fashion houses. A La Carte

sold gorgeous custom-designed clothes, while The Gilded Lily specialized in European ready-to-wear. At Kaleidoscope, here and at the later location on 58th Street (*see below*), one could find vintage fashion along with a variety of antiques including Victorian figurines, old vending machines, and silver hairpin boxes in what Morse called "a country store with mostly old American things." Andy Warhol was an avid collector much like her, and they quickly became friends. Morse's nickname and boutique derived from the poem by William Blake; Warhol and his colleagues often referred to her as the Gilded Lily Lady. She was happy to accept Warhol's cheerful blotted-line drawings to put up in her shop on consignment in the late fifties. Joan Morse had a penchant for business, notably from her father, the architect M. Henry Sugarman, who designed the New Yorker Hotel.

Joan Morse quotes:
"I can't sew, drape, or cut a pattern. But I play with a piece of fabric and it comes up wild and it sells."
"I'm a swan in a world of ducks."
"A lot of people have called me a witch because I can read their coffee grounds."
She called her fashion "queer and fantastical quiddities."
"They're afraid of what's happening ... they even preached about that terrible shop in their churches."
"They think I'm salvation."
"I have a hangup on sunglasses." (She owned eighty pairs.)
"Isn't it wild?" (her favorite expression)

29
Kaleidoscope
1965
14 East 58th Street (Fifth Ave./Madison Ave.)
☆
Joan "Tiger" Morse moved her fashion-forward boutiques here in April 1965 under the single name

Kaleidoscope. Her client list had expanded since relocating from her store on 63rd Street. She acquired a small army of seamstresses all ready to apply beads and brocade onto dazzling silk, gold-strewn paisley and flowered prints, embodying the sixties fashion revolution. Morse, a modern day explorer, boasted of thirteen round-the-world tours to find exotic silks and other fabrics for her shop.

She often encouraged Warhol and his entourage to come up to her shop for impromptu parties where films were screened and reflected off the mirrored tiles lining the walls—much like an actual kaleidoscope. Warhol would make several films of Tiger Morse and included a segment in his December 1967 twenty-five-hour film ****, which featured her against a silver background of lights and costumes and was simply titled *Tiger Morse*.

30
Teeny Weeny
1960s
922 Madison Avenue (near 73rd St.)

By August 1966, Tiger Morse moved uptown again, to Teeny Weeny on Madison. Before long, Tiger Morse's designs were celebrated in *Life* magazine and worn by women in power who wanted to make a splash. Jackie Kennedy and furniture designer Florence Knoll, among others, had been photographed in Tiger's creations. She also had shops in London and Chicago. She eventually took over the Cheetah Boutique in April 1966 at New York's famed Cheetah Club, renaming it Tiger's Toys (1680 Broadway at 53rd St.) and setting fashion trends for devotees of the nation's best-known discotheque.

She died in London at the age of forty on April 22, 1972.

31
Bodley Gallery
1956–1959
223 East 60th Street (Second Ave./Third Ave.)
☆

In 1956, Warhol had a show of some recent work at
the Bodley Gallery, under the reins of David Mann, who
had overseen Warhol's Capote show at the Hugo Gallery.
Warhol's figure drawings titled *Drawings for a Boy Book*,
like his preceding shows at the Loft Gallery, drew little
attention.

He would show three more times at the Bodley:
his fanciful *Crazy Golden Slippers* in 1956 (profiled
in a two-page spread in *Life*), the *Gold Pictures* show in
1957, and eventually his collaboration with decorator
Suzie Frankfurt, *Wild Raspberries* in December 1959.
This last show consisted of whimsical illustrations by
Warhol surrounding Frankfurt's imaginative recipes. At
the time, Mann priced the original drawings between
$100 and $150 and bound copies of a set of reproduc-
tions for $15. This "cookbook," reprinted in 1997, took
its name from *Wild Strawberries*, the Ingmar Bergman
film, which played in New York earlier that year.

32
Serendipity 3
mid-1950s–1960s
225 East 60th Street (Second Ave./Third Ave.)
✳

Andy Warhol was drawn to Serendipity when it opened
as a dessert boutique in 1954, located at the time
in a basement at 234 East 58th Street. Serendipity
was started by three partners: Stephen Bruce, Patch
Carradine, and Calvin Holt, Warhol's neighbor at 242
Lexington Avenue. Early on, Warhol understood that
Serendipity was a meeting place for art directors and he
did his best to charm his way into new jobs. The own-
ers encouraged Warhol to hang his drawings on the

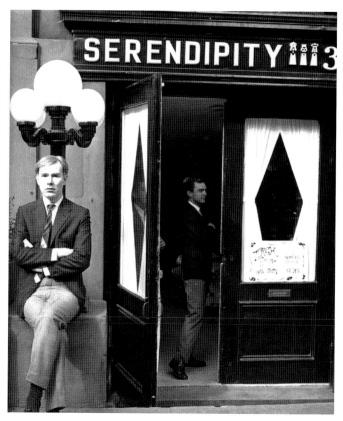

John Ardoin: Andy Warhol, at left, and Stephen Bruce in the doorway at Serendipity 3, 1962.
Photo © Serendipity 3. Courtesy of Stephen Bruce.

walls; some shoe drawings mounted as *A la Recherche du Shoe Perdu* sold within a matter of days, and he was motivated to seek out a proper gallery.

The astute vision the three men shared would soon be recognized by crowds lining the block for their frozen hot chocolate, and the chance to catch a glimpse of a celebrity amid the Tiffany-shaded decor. Today, after fifty years, the crowds keep coming.

33
Lester Persky Residence
1960s
400 East 59th Street (First Ave.)

The ad man and later Hollywood producer Lester Persky, who claimed responsibility for discovering Edie Sedgwick (though Diana Vreeland also made the same claim years later), introduced Sedgwick to Warhol at a birthday party for Tennessee Williams held here in early 1965. Persky was known for throwing parties, and in May he gave the Fifty Most Beautiful People party at the Silver Factory on 47th Street, which boasted a who's who of New York's social scene featuring Sedgwick and including, among others: Tennessee Williams, Rudolf Nureyev, Judy Garland, and Montgomery Clift. Warhol's book, *a: a Novel*, which was configured to be a day in the life of Factory regular Ondine, featured more than two chapters of conversations set here in Persky's apartment. Persky is recognizable throughout as the character Irving du Ball.

34
Paulette Goddard Residence
1970s
320 East 57th Street (First Ave./Second Ave.)

Goddard, formerly a Ziegfeld Follies girl, as well as an actress in movies from Charlie Chaplin's *Modern Times* to Renoir's *Diary of a Chambermaid*, was linked romantically over the years to Chaplin, Burgess Meredith, and the novelist Erich Maria Remarque (*All Quiet on the Western Front*), who resided at this address starting in the 1950s. Goddard moved in shortly thereafter and married Remarque, who died in 1970.

Warhol and Goddard became close friends during the early seventies after an art gala at the Metropolitan Museum. As he was often out and about in the sixties with Edie Sedgwick, Warhol and Goddard were soon

seen everywhere together. Warhol had been tape recording the star's life story for a book to be titled either *Her, Andy Warhol's Paulette Goddard*, or *The Movie Star*, but when Goddard was less than forthcoming with intimate details of her past, the deal fell apart and they went their separate ways. The book, which was eventually completed, has never been published.

35
Bloomingdale's
1950s, 1960s, 1970s, 1980s
1000 Third Avenue (59th St./60th St.)
✷

For Warhol, the shopping experience at Bloomingdale's was unparalleled: it represented for him a type of emotional Valhalla. When asked about his mother, who had returned to Pittsburgh in 1971 when her health deteriorated, Warhol was known to simply say that she had gone to Bloomingdale's.

As one of the first destinations on his daily routine, Warhol could be found chatting with a familiar sales person, then turning to pose for a snapshot for an admirer.

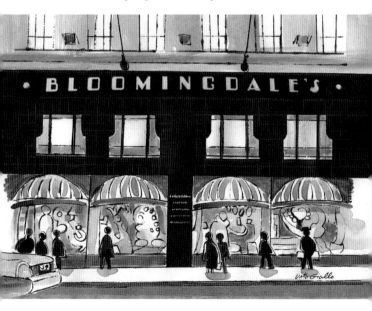

Elaine's Restaurant

1703 Second Avenue (88th St.)

To this day a favorite nightlife staple for the celebrity crowd, this renowned eatery fascinated Warhol soon after it opened in 1963. He delighted in being surrounded by famous people, so he dined here regularly well into the eighties. Elaine Kaufman, the hostess who prefered to be called Mama, held a watchful eye over this place from its inception until her death in 2010.

Three Guys Restaurant

960 Madison Avenue (75th St./76th St.)

Andy Warhol was a regular at this diner, just steps from the Carlyle Hotel, starting each day in hopes of running into well-known acquaintances, or eyeing a celebrity enjoying the plain comfort food after being out all night. He and his assistant, Benjamin Liu, would catch up on the previous evening's gossip and Warhol would chase scrambled eggs around a plate before running off for an afternoon of shopping at antique and department stores to find new pieces for his ever-growing collections.

Quo Vadis, then changed to Orsini's

26 East 63rd Street (near Madison Ave.)

A regular haunt for Warhol in the late fifties/early sixties, this coffee-shop-turned-Italian-restaurant, boasting Upper East Side royalty and a celebrity clientele, was perfect for sipping drinks and people watching; it has now closed.

Café Nicholson

323 East 58th Street (First Ave./Second Ave.)

Though now closed, this upscale restaurant known for attracting actors, writers, and wealthy society patrons was a favorite of Warhol's during the fifties, sixties, and

into the seventies. He splurged on lavish dinners with close companions, and once, after a Factory party, accompanied Judy Garland and several other guests here and dined on spaghetti, one of Garland's favorite foods; she obliged the diners with her incredible voice by singing songs late into the evening.

Warhol ate at these six upscale restaurants on a weekly basis during the fifties, sixties, seventies, and eighties:

21 Club

21 West 52nd Street (Fifth Ave./Sixth Ave.)

La Grenouille

3 East 52nd Street (Fifth Ave./Madison Ave.)

Brasserie

100 East 53rd Street (Park Ave./Lexington Ave.)

Russian Tea Room

150 West 57th Street (Sixth Ave./Seventh Ave.)

Gallagher's Steak House

228 West 52nd Street (Broadway/Eighth Ave.)

Sardi's

234 West 44th Street (Seventh Ave./Eighth Ave.)

36
Plaza Hotel
1950s, 1960s
768 Fifth Avenue (Central Park South)

The Plaza, nicknamed for its location near Grand Army Plaza at 59th Street and Central Park, is the quintessential New York hotel (partially turned condo), boasting an eventful history populated with literary and screen personalities. The building captivated Andy Warhol, more for its wealthy and famous guests than for the Plaza's landmark status. He dined here often after first coming to New York in the 1950s, hoping to run into an actor, dancer, or other person of renown in the stunning Palm Court, whose stained-glass ceiling has been fully restored.

In 1966, Warhol attended Truman Capote's legendary Black and White masked ball here, allowing him to be near his boyhood idols, Vivian Leigh, Greta Garbo, Tallulah Bankhead, and Marlene Dietrich; to chat with Cecil Beaton, Norman Mailer, Philip Johnson, Edward Albee, Richard Avedon, George Plimpton, and Tennessee Williams (who had been a recent guest at his Silver Factory); and to rub shoulders with Frank Sinatra, Brooke Astor, Billy Wilder, Mrs. Nelson Rockefeller, Oscar de la Renta, and Jackie Kennedy. Also here were Diana Vreeland and Lee Radziwill, both of whom became close Warhol friends and were often photographed with him by the paparazzi. Capote received the nickname of Truman Caparty in the local press.

37
FAO Schwarz
1950s, 1960s, 1970s, 1980s
767 Fifth Avenue (58th St.)

Warhol had an abiding fondness for the miles of merchandise that could be bought at this toy store,

formerly at 745 Fifth Avenue. He always had an eye out for the next big thing and kept special items in mind for friends, family members, and himself. While exiting the store one day with a giant teddy bear, he ran into Salvador Dali's wife, Gala. She proceeded to confess her love of teddy bears and snatched the bear from him— to his amazement. Warhol had been amassing all types of collectible items, including toys, ever since he moved to New York, but it seemed as though the best toys to Warhol were the ones that would remain in their boxes and someday go up in value.

38
Bonwit Teller—RAZED
1950s–early 1960s
721 Fifth Avenue (56th St./57th St.)
The production office of this upscale department store was located on the tenth floor of a 1929 Warren and Wetmore Art Deco monolith, overlooking Tiffany's, with a view of Central Park. Andy Warhol began working for Bonwit's in 1954, illustrating shoes for advertisements in various publications, including *The New York Times*.

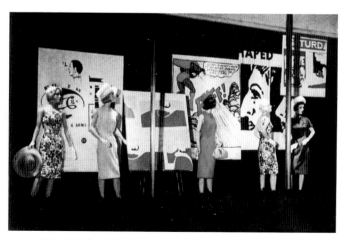

Window display, Bonwit Teller, New York, April 1961. Collection of The Andy Warhol Museum, Pittsburgh. © 2011 The Andy Warhol Foundation for the Visual Arts, Inc./ Artists Rights Society (ARS), New York.

He also picked up some extra work at Bonwit's doing weekly window displays for Gene Moore, the display director, and later Daniel Arje, who took over for Moore in 1960. As had a variety of other Bonwit-employed painters from Salvador Dali to Jasper Johns, Warhol displayed his paintings, starting with his first Pop Art pieces, as backdrops for the latest fashions. Warhol now had many clients and when the prospect of becoming a "real" artist started to become more of a possibility, he lost interest in the commercial work.

For years, Bill McCarthy, the advertising director, would take it upon himself to destroy anything left by artists who failed to come in and pick up their work, pleading limited space. He recalls slashing through dozens of Warhol shoe drawings, worth many thousands of dollars in today's market, with a razor blade.

The building, with its beautiful ironwork and Art Deco bas-reliefs, was razed in 1980 to make way for Trump Tower.

39
I. Miller
1950s–early 1960s
689 Fifth Avenue (54th St./55th St.)
☆

The production office for the stylish shoe store I. Miller was just around the block from where Warhol had his first show of drawings (based on the writings of Truman Capote) in 1952 and two blocks from Bonwit's. In 1955, Warhol started working for I. Miller and held the position into the early sixties, becoming chief illustrator for the company. He worked quickly and would come into the office often, to make changes or finish up an illustration at the direction of the production department.

Actor Tom Lacy, who worked at both I. Miller and Bonwit's with Warhol, recalls coming into the building one morning in the early sixties; he and Warhol needed to drop off some artwork and had plans

later on that afternoon. When they stepped into the elevator, they were surprised to hear music playing— the first elevator music. They glanced at each other and without saying a word comically slow-danced until they got to their floor.

The building, formerly named the Aeolian, was redesigned in 1970 when I. Miller moved out, and now supports two different storefronts. The stainless steel used to reinforce the façade spells out the name of the tenant since 1930, Elizabeth Arden.

40
Cinema Rendezvous
1966
110 West 57th Street (Sixth Ave./Seventh Ave.)

This building is currently home to the DGA (Directors Guild of America), but this address made headlines when Warhol's epic film, *The Chelsea Girls*, appeared here in December 1966 after emerging from the underground. The film had been publicly shown for the first time in the basement of the Wurlitzer Building earlier in the year, but the small theater there couldn't contain the large crowds that appeared night after night. For the film's first run in a mainstream cinema, prices were raised from two to three dollars for the three-and-a-half-hour evening and weekend screenings.

Weekly screenings of new film releases are currently shown to SAG members here.

41
Pace Gallery
1964
9 West 57th Street (Fifth Ave./Sixth Ave.)

In January 1964, Warhol contributed an "invisible" painting to Pace's *First International Girlie Exhibit*: one close-up image of a woman's breasts printed nine times

that could only be seen by black light. Due to strict laws at the time, any gallery could be fined for exhibiting indecent materials, but Warhol thought that if they simply switched on the lights when law enforcement arrived, the paintings would appear blank. One reviewer thought the ideal solution of invisible ink might fix the "whole pop art problem."

42
Betty Parsons Gallery
1963
24 West 57th Street (Fifth Ave./Sixth Ave.)

When Betty Parsons held a large group show in December 1963, titled *Toys by Artists*, thirty-four artists exhibited, including Warhol, Marisol, Alexander Calder, and Agnes Martin. Warhol's gallery submission consisted of a dozen T-shirts screened with images from his *Tuna Fish Disaster* paintings, each priced at $300.

For the other artists in the show the focus on "toys" implied some relationship to a younger audience. But Warhol's toys were adult-sized T-shirts, printed with a giant tin of tainted A&P tuna fish and the faces of a Mrs. McCarthy and a Mrs. Brown (who had succumbed to botulism–induced respiratory failure only nine months before). Warhol may have intended the work for a more mature crowd, or a more facetious one. A reviewer wrote that Warhol's work "suggests neither a game nor a philosophical question" as the other toys might have. Or it might have simply been a sick joke.

43
Carnegie Hall Cinema
1965
883 Seventh Avenue (56th St./57th St.)

Beginning Monday, March 1, 1965, Warhol screened films here in a commercial theater for the first time.

Though the films were never projected inside the actual cinema, a twenty-four-minute piece played in a continuous loop in the lobby. Originally scheduled to run for several weeks and advertised as *Six of Andy Warhol's Most Beautiful Women*, the six screen tests—including actresses Sally Kirkland and Beverly Grant, models Ivy Nicholson and Baby Jane Holzer, children's book writer Isabel Eberstadt, and Ann Buchanan in the "portrait of a girl who cried"—were shown for only a few days.

The cinema space then run by Sid Geffen, located one level below the main hall, has since returned to its original role of recital hall; it reopened in September 2003 as Zankel Hall.

44
55th Street Playhouse
1969
154 West 55th Street (Seventh Ave./Broadway)
☆

This unique 1927 building, designed by an architectural team specializing in Palm Beach mansions, had, by the late fifties, become an art-house theater showing experimental films. Andy Warhol's *Flesh* and *Lonesome Cowboys* each played here in May 1969. Both films had opened downtown at the Garrick Theatre before moving uptown. The outrageous cowboy flick broke the single-day house record, taking in $3,837 at $3 per ticket.

The theater became a porn outlet for a decade before being gutted and turned into office space. It now sits demurely in close proximity to Times Square without offering the slightest hint of its decadent past.

45
Studio 54
1977–1980
254 West 54th Street (Broadway/Eighth Ave.)
☆

Ian Schrager and Steve Rubell's world-famous disco-
theque opened in April 1977. Those who made it past
the red velvet ropes and onto the dance floor recalled
feeling like instant celebrities. Halston, Calvin Klein,
Bianca Jagger, Andy Warhol, Truman Capote, and Liza
Minnelli were known to hold court in a select area of
the club; at a certain time, a curtain was raised reveal-
ing the troupe to the crowd. Other celebrities such as
Divine, Michael Jackson, Diana Ross, Elton John, Cher,
and Brooke Shields created nightly sensations among
the largely gay crowds.

Soon, Studio 54 would be better known for its
drug culture than as a house of fame and fashion. The
lights went dim in 1980 when the government cracked
down on Schrager and Rubell. Loads of cash were found
in the club's ceiling and the duo were convicted of
tax evasion.

The club opened again in September 1981 under
new ownership, but disco was dead. It remained in
business until 1986 and then reemerged in the early
nineties, but the building was slated for demolition
in 1996. The Roundabout Theatre came to the rescue,
moving in their wildly successful musical revival of
Cabaret starring Alan Cumming, and eventually pur-
chased the building in 2003.

Originally a 1927 opera house, the theater boasts
a rich tradition including performances by Antoinette
Perry, who bequeathed her name to the Tony Awards,
and a later life as a CBS studio for Jack Benny, Jack
Paar, and Johnny Carson.

46
The Museum of Modern Art
1950s, 1960s, 1970s, 1980s
11 West 53rd Street (Fifth Ave./Sixth Ave.)

Andy Warhol's work appeared in a group show here titled *Recent Drawings—USA* in April 1956. The press release for the show mentions 150 works from twenty-seven states selected from 5,000 submissions, from famous artists to unknowns. In October of that year, Warhol took it upon himself to contribute a shoe drawing to the museum's permanent collection and was turned down by museum director Alfred Barr and the committee due to "severely limited gallery and storage space."

MoMA now holds at least a dozen early shoe drawings alongside many *Marilyns*, *Flower Paintings*, *Electric Chairs*, and a silver double *Elvis*. The museum is fortunate to also have the original thirty-two *Campbell's Soup Can* paintings initially shown at the Ferus Gallery in Los Angeles in 1962. MoMA presented a Warhol retrospective from February to May 1989.

The MoMA film department holds regular screenings of experimental works and has nearly complete film collections of three of America's most influential filmmakers: D. W. Griffith, Stan Brakhage, and Andy Warhol.

47
Time-Life Building
1964
1271 Sixth Avenue (50th St./51st St.)

Empire State Building
1964
350 Fifth Avenue (33rd St./34th St.)

In 1964, all eyes were fixed on the tallest building in Manhattan. Lights had been installed illuminating the

top thirty floors of the Empire State Building to mark the opening of the New York World's Fair in April. Warhol and John Palmer had the idea to bring the image of the magnificent building to the world by recording an evening view of the newly-lit tower on film. The crew consisted of Warhol, Palmer, Gerard Malanga, Marie Desert, Jonas Mekas, and Henry Romney, an executive of the Rockefeller Foundation whose 41st-floor office was used for the shoot; they were armed with an Auricon camera and ample reels of unexposed film. Mekas recorded the evening and transcribed high-lights of the night in *The Village Voice* in 1964.

Warhol spent the evening reading from an Empire State Building visitor's guide and making exclamations regarding the building's stature and star power—"The Empire State Building is a star!"—while repeatedly ignoring requests to pan the camera. During filming, it was suggested they create a wall of glass panels in a theater so that an audience could view the screening just as they filmed it. The result was *Empire*, a relent-less, eight-hour, unpanned portrait of the Empire State Building.

Some critics had actually complained when *Sleep*, advertised as an eight-hour film, turned out to be *only* five hours and twenty minutes long. So this time they went for the full eight, following Warhol's anthem: "Always leave them wanting less."

Empire was screened at City Hall Cinema at 170 Nassau Street on Saturday March 6, 1965, beginning at 8:30 PM. Theatergoers were encouraged to bring coffee and sandwiches. It would not be the longest film Warhol would create (see the twenty-five-hour ****) or hope to create; in an interview with Jonas Mekas dur-ing filming, Warhol spoke about making a film version of the Old and New Testaments that would run for thirty days, titled *Warhol Bible*.

vito Giallo

Saint Patrick's

48
St. Patrick's Cathedral
1987
Fifth Avenue (50th St./51st St.)

✳

This Gothic Revival cathedral currently hosts the oldest
Roman Catholic parish in New York City and was the
largest church in the United States when it opened in

1879. The church seats just under 2,200, holds mass on a daily basis, and is the starting point for New York's annual Easter Parade. St. Patrick's has been home to countless weddings including Zelda and F. Scott Fitzgerald's, and memorial services for many including Joe DiMaggio, Robert F. Kennedy, Vince Lombardi, and Babe Ruth. Jacqueline Bouvier Kennedy's daughter, Caroline, was christened here in the Bouvier Chapel.

On Wednesday, April 1, 1987, the church was filled with a who's who from the celebrity and art worlds for the hour-long funeral service for Andy Warhol. Warhol's longtime associate and close friend Brigid Berlin read from the *Book of Wisdom*; Yoko Ono spoke of Warhol's mentor relationship to her son, Sean, after her husband John Lennon's death; the art historian John Richardson read the eulogy.

Warhol Factory members and celebrity guests in attendance included: Viva, Gerard Malanga, Ultra Violet, Baby Jane Holzer, Roy Lichtenstein, Jamie Wyeth, David Hockney, Julian Schnabel, Fran Lebowitz, George Plimpton, Calvin Klein, Holly Woodlawn, Frederick Hughes, Diane von Furstenberg, Liza Minnelli, Richard Gere, Grace Jones, Claes Oldenberg, Halston, Robert Mapplethorpe, Steven Sprouse, Debbie Harry, Bianca Jagger, Ahmet Ertegun, Francesco Clemente, Keith Haring, Henry Geldzahler, Sylvia Miles, and Paloma Picasso.

49
Rainbow Room (in the RCA Building, now the GE Building)
1965
30 Rockefeller Plaza
☆

On November 16, 1965, a group named Le Cercle d'Or rented out the 65th-floor Rainbow Room for a Mod Ball. Jerome Brody, Inc., the event management company there, became suspicious of the so-called private

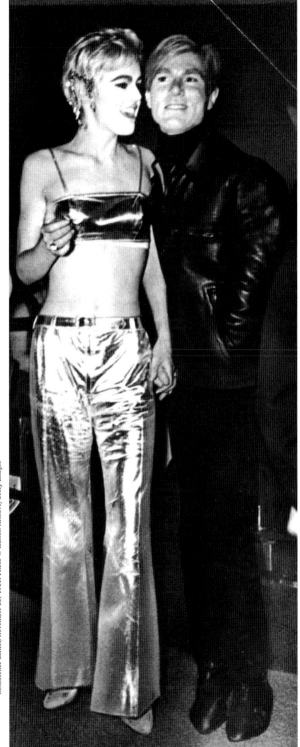

Edie Sedgwick and Andy Warhol at the Mod Ball, a party held in the Rainbow Room of Rockefeller Center, November 22, 1965. Photo © Hulton Archive/Getty Images

party when posters appeared all over town indicating that for only $25, anyone could attend. The management beefed up security, stationing police officers at the entrance, but it had to deal with an army of Mod posers trying to crash the Ball.

All eyes were on Edie Sedgwick and Andy Warhol when they walked into the Rainbow Room. Edie had on huge silver earrings and a matching silver bell-bottomed pants suit. When the temperature rose, she tossed off the jacket to reveal a tiny silver bra. Warhol dressed in his classic black leather jacket and black pants with his iconic silver wig.

50
Silver Factory—RAZED
1964–1967
231 East 47th Street (Second Ave./Third Ave.)

Completed in 1887, the five-story building that housed Andy Warhol's Silver Factory was originally the Peoples Cold Storage and Warehouse. The structure stood on the site of the former F.A. Neumann Brewery, which sold lager beer in the mid- to late 1800s. Over the years, it housed many businesses including an electrical workstation, a cigar manufacturer, and a few woodworking operations. The fourth-floor Factory space had likely housed an upholsterer's shop that outfitted newly-made furniture (Decorators Upholstery), not, as is commonly thought, a manufacturer of hats. In 1887, the building's owners installed the Patent Friction Rolling Elevator, one of the oldest and earliest elevators in the city; its slow crawl to the fourth-floor Factory became legendary in the sixties.

The Factory occupied nearly 3,000 square feet with the length just under 75 feet (74.9) and the width just short of 40 feet. When Warhol moved into the new space in January 1964, he began work right away. His friend and former lover, Billy Linich (who once worked as a waiter at Serendipity 3), was asked to turn the

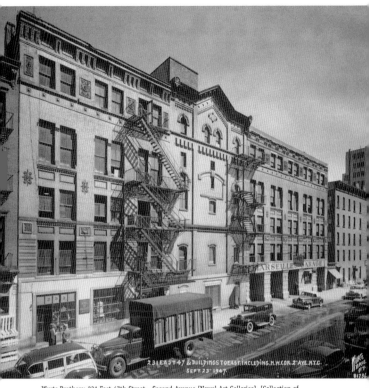

Wurts Brothers: 231 East 47th Street—Second Avenue [Newel Art Galleries]. [Collection of photographs of New York City.] [Wurts Brothers, photographer] / Manhattan. Sept. 23, 1947. Milstein Division of United States History, Local History & Genealogy, The New York Public Library, Astor, Lenox and Tilden Foundation

crumbling space into a more suitable environment. Warhol had been to visit Linich at his apartment at 272 East 7th Street, where Linich was known to host hair-cutting parties. He had decked out his place with loads of silver paint and aluminum foil. Warhol thought the look would work well at his new loft. Within a matter of days, Linich, who would later change his name to Billy Name, began the installation that provided Warhol with a signature style and helped project a silver sixties attitude reflected worldwide.

Soon, Warhol, with the help of Linich and Malanga, began creating a series of sculptures: painted plywood boxes resembling shipping cartons for Heinz

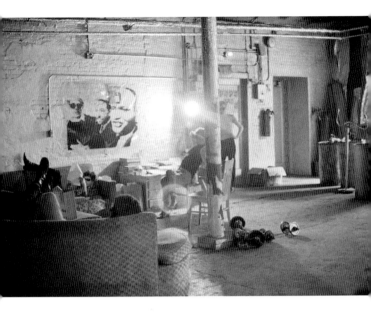

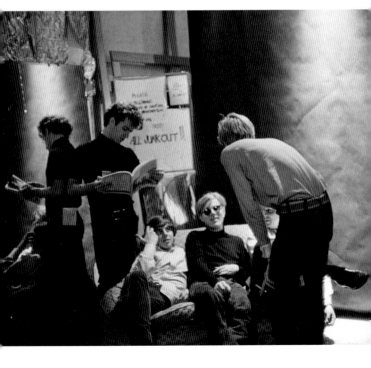

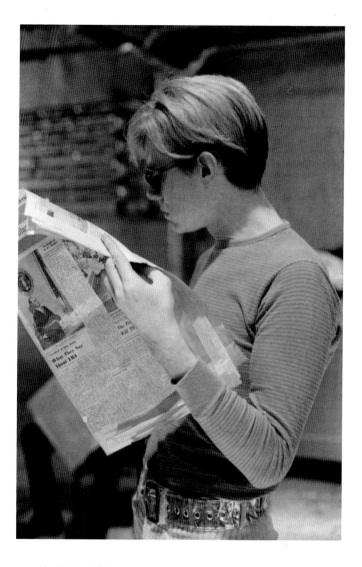

Gretchen Berg: Top left, Lou Reed on the sofa, Joseph Freeman with back to camera, and Andy Warhol in the Silver Factory, 1966. © 2011 The Andy Warhol Foundation for the Visual Arts, Inc./ Artists Rights Society (ARS), New York; Bottom left, from left, Gerard Malanga, Joseph Freeman, Andy Warhol, Rene Ricard (with back to camera) and unidentified man in the Silver Factory, 1966; Above, Andy Warhol reading the *Village Voice* in the Silver Factory, 1966. All photos © Gretchen Berg.

Ketchup, Kellogg's Corn Flakes, Mott's Apple Sauce, and Brillo Soap Pads. The boxes were ordered from a nearby carpentry shop and constructed offsite (at Havlicek Woodworking, 409 East 70th Street); once delivered, they were set up in rows, hand-painted and then screened, in a process much like that of a factory assembly line. By April, Warhol's new works would be the feature of his show at Eleanor Ward's Stable Gallery.

When the boxes garnered negative reviews, Warhol didn't stop painting. He immediately went to work on a series of *Flower Paintings* whose image was appropriated from a photo of hibiscus blossoms by Patricia Caulfield in the June issue of *Modern Photography*. The *Flowers* were hung in November 1964, with his new dealer Leo Castelli, and proved the artist was hitting his mark in the art world once again; the show became a sellout.

By summer of the following year, Warhol announced his retirement from painting in Paris, aping Duchamp. He focused on becoming a filmmaker and continued creating works to add to the film portfolio he began in 1963. The film business was not unknown in the Factory area. In 1916, Joseph Schenck turned a former brewery, one block east at 318 E. 48th Street, into a motion picture studio, where Buster Keaton appeared in his first film, *The Butcher Boy*, and Norma Talmadge produced movies.

By 1966, Warhol had shot hundreds of rolls of film creating a series of screen tests (nicknamed "stillies" at the Factory) where visitors would walk in and be asked to sit for a film portrait lasting about three minutes in length. The sitter posed without any instructions and Warhol would often leave the camera unattended during the shooting, abandoning his subjects to apprehension and anxiety. Works filmed at the Silver Factory include scenes for *Vinyl*, *Screen Test #2*, *Horse*, *The Life of Juanita Castro*, and *The Chelsea Girls*, all of which have scenarios written by playwright and screenwriter Ronald Tavel.

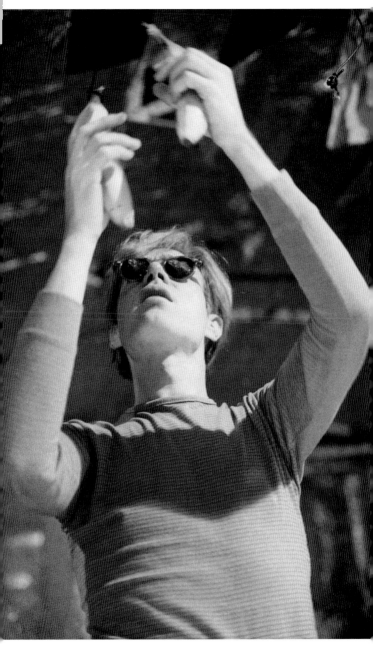

Gretchen Berg: Andy Warhol hanging bananas from the ceiling of the Silver Factory, 1966.
© Gretchen Berg. © 2011 The Andy Warhol Foundation for the Visual Arts, Inc.

After the success of *The Chelsea Girls* and the loss
of the lease on the building at the end of 1967, Andy
Warhol and his company moved the Factory to Union
Square. The tired building would be torn down by 1969
to create 1 Dag Hammarskjold Plaza. The original loca-
tion of 231 can be found by measuring 150 feet west of
Second Avenue on the north side of 47th Street.

Several Warhol books were created here: *a, a Novel*,
Andy Warhol's Index Book, and the Stockholm Catalogue
(where first appeared the phrase: "In the future, every-
one will be world-famous for fifteen minutes").

51
41st Street Theater—RAZED
1965–1968
125 West 41st Street (Sixth Ave./Seventh Ave.)
Starting in December 1965, Jonas Mekas's Film-makers'
Cinematheque moved to this 199-seat theater space in
the basement of the Wurlitzer Building, built near Times
Square in 1919. The experimental screenings featured
work by Jack Smith, Bruce Conner, Warren Sonbert,
Marie Menken, Andy Warhol, and many others. Warhol
presented a multimedia event here titled *Andy Warhol,
Up-Tight* beginning Tuesday, February 8, 1966. For the
$1.50 admission, one could see several Warhol films
projected across a small crowd of performers featuring
Edie Sedgwick and Gerard Malanga, while The Velvet
Underground played. The shows grew in popularity and
relocated to the Open Stage on St. Mark's in April.

By September, Mekas's Cinematheque was $2,000
in debt and only a miracle could save the weekly
screenings of experimental films. Luckily for Mekas, on
September 15, 1966, Warhol presented a split-screen,
loosely based narrative of various story lines set in dif-
ferent rooms at the Chelsea Hotel. The three-hour-plus
film, *The Chelsea Girls*, quickly became a smashing suc-
cess and ran frequently until December, when it moved
to the upscale Cinema Rendezvous on 57th Street to

accommodate larger crowds. A complex odyssey through the theaters of Manhattan ensued.

By the start of 1967, the film moved again to Brandt's Regency Theater at 1987 Broadway (67th St./ 68th St.), then a month later to the York Cinema at 1187 First Avenue (64th St.). When Warner LeRoy purchased the building and turned the theater into the restaurant Maxwell's Plum, the screenings were relocated yet again at the end of April, this time downtown to St. Mark's Theatre at 133 Second Avenue.

On July 12, 1967, the film returned to the 41st Street Theater. When *The Chelsea Girls* moved back to the Wurlitzer Building this second time, the building was in need of a makeover. Jack Smith advertised in the paper looking for volunteers to help paint the ceiling. The theater soon closed to outfit an entrance on 42nd Street to take advantage of the Times Square crowd.

In March 1968, *The Chelsea Girls* would return once again to the Wurlitzer Building, where the theater was now called the 42nd Street Playhouse. In the years that followed, Times Square deteriorated and the basement theater became host to adult films. The building was torn down in 1972.

52
Hairpieces by Paul—RAZED
1970s–1987
147 West 42nd Street (near Seventh Ave.)

Warhol began to wear hairpieces in the mid-fifties when his boyfriend, Carl Willers, was embarrassed that he wore caps indoors at expensive restaurants. Though initially worn to cover his balding head, the wigs became his calling card, a vital part of his image, virtually defining a new self for Warhol. At home, he spent hours dyeing the lower portion of the back of each wig a dark color, giving it the appearance of real hair sticking out at the back—even though his gray hair also poked out from under the back of the hairpieces. Warhol

came to be known in the world not only for his artwork but for his wigs. He purchased hundreds of wigs, two at a time, from this shop on 42nd Street starting in the early seventies. Paul (Bocchicchio) personally delivered the wigs to the Factory.

53
Hudson Theater
1967–1968
141 West 44th Street (Broadway/Eighth Ave.)
✳

This 1903 theater with a Beaux Arts façade has had a rich history in Times Square. Built by Henry B. Harris, who perished on the *Titanic* in 1912, the Hudson featured early performances by William Holden, Edward G. Robinson, Douglas Fairbanks, and Helen Hayes before Mrs. Harris, who survived the *Titanic*, sold it to CBS in 1934.

The theater changed ownership over a dozen times and became an NBC television studio by the early fifties. *The Tonight Show* with Steve Allen and *The Price Is Right* with Bill Cullen both premiered here. Barbara Stanwyck's stage debut and Barbra Streisand's first television appearance both took place at the Hudson. Elvis Presley also performed here, on *The Steve Allen Show*, vowing never to come back when the host was less than supportive of his talent. By the mid-sixties, the theater no longer housed NBC, but instead, bawdy burlesque shows.

In July 1967, Warhol's film *My Hustler*, which had played for several months at the 41st Street Theater, relocated to the Hudson. *My Hustler* would show here on and off until February 1968 along with *Banana*, *Nude Restaurant*, *Bikeboy*, and *I, a Man*, featuring Valerie Solanas, who shot Warhol in 1968.

The theater has experienced a revival since receiving landmark status in 1987, and a restoration of its original decor in 1990. Adjacent to the Millennium Broadway Hotel, the Hudson is one of the last remaining gems in the Times Square area.

54
Loft Gallery—RAZED
1954–1955
302 East 45th Street (First Ave./Second Ave.)

Artist Vito Giallo appropriated the front room of Jack
Wolfgang Beck's large loft space here to hold art exhib-
its beginning in 1954. Giallo, along with his friends
Nathan Gluck and Clint Hamilton, deliberated over
who should be invited to be a part of the gallery. They
decided to ask Andy Warhol to join the collective.

The first show opened on April 9 with seven art-
ists: Beck, Giallo, Jacques B. Willaumez, Edward Rager,
and three Carnegie Tech alumni: Allan Hugh Clarke,
Gillian Jagger, and Andy Warhol. Warhol's work resem-
bled more of an installation than a show of traditional
paintings. He drew small figures on pieces of marbled
Strathmore paper, then folded them into large pyrami-
dal shapes. The ten or so works were pinned to the
wall, but the weight made them fall to the ground more
often than not. Reviewers nicknamed the works "crum-
pled" drawings, after repeated falling and re-pinning.
On May 17, Warhol was part of a group show including
Allan Hugh Clarke and Edward Rager, but this time he
illustrated poems and hung them in a conventional
manner. They reminded one reviewer of unrefined imi-
tations of Jean Cocteau drawings.

Warhol's last show at the Loft would be his first
solo New York show, opening October 10, 1954, and
featuring drawings of the famous dancer John Butler.
Giallo remembers that they were astounded when John
Butler came to the show. The dancer received several
drawings from Warhol in 1954.

By the summer of 1955, the Loft Gallery would
close, ending with a show of collages by Clint Hamilton.
Giallo, who had managed the gallery, immediately
started to work for Warhol.

55
New York Public Library
1950s
Fifth Avenue and 42nd Street
✳

In the early fifties, Warhol used the New York Public Library to find images for his drawings. He had made the acquaintance in 1953 of a library employee, Alfred Carlton Willers, or Carl, who became his boyfriend. Willers kept him supplied with photos from the library archives to copy. Warhol would also use periodicals such as *Life* or *Dance* for source material, holding onto recent issues for months.

For his commercial work, he transferred the magazine images onto paper using a light board, and then used his blotted-line technique to make the drawings appear printed and/or manufactured.

Warhol first learned how to copy pictures in grade school. "The teachers liked me. In grade school, they make you copy pictures from books. I think the first one was Robert Louis Stevenson."

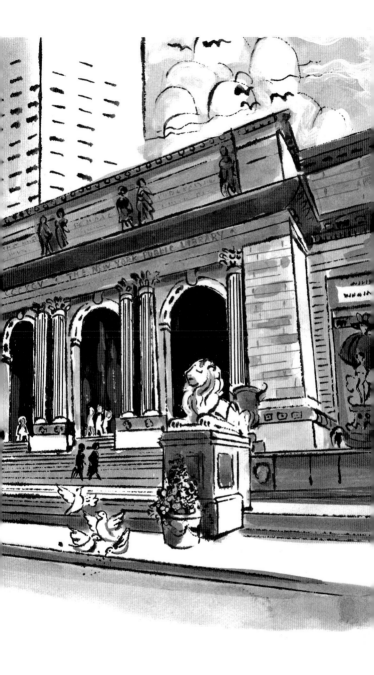

56
Andy Warhol Residence—RAZED
1953–1960
242 Lexington Avenue (34th St./35th St.)

Warhol and his mother moved to the top floor of a four-story apartment building on Lexington Avenue in 1953 where fellow Carnegie Tech graduate and illustrator Leonard Kessler lived. By this time, tales of Warhol's unstable apartment sublets and varied employment situations had been carried back to Carnegie Tech. Teachers were known to regularly warn the students that they needed to be more careful or they would end up like Andy Warhol.

Vito Giallo, the artist in charge of selecting artists for shows at the Loft Gallery, became friendly with Warhol from their first meeting and agreed to show his work. Warhol later asked Giallo to work for him on his commercial advertising assignments after the Loft Gallery closed in the summer of 1955. Giallo recalls coming to the Lexington Avenue apartment and noticing that the space was sparsely furnished with only a television, a desk, and a light box with an odd chair or two. The galley kitchen was a separate space across from a small storage room. In the bedroom, nearest the bathroom, there were two bare mattresses next to each other on the floor where Warhol and his mother each slept.

Giallo found the working atmosphere a bit chaotic. The television was almost always on, and several Siamese cats would always be playing—romping their way back and forth through the apartment. Giallo remembers Warhol's mother, Julia, as a relentless force in her son's life. She constantly pushed food onto her son and his guests, and she obsessively doted on Andy. After arriving one morning, Giallo asked Mrs. Warhola how she had slept and was surprised to hear her say she'd stayed up all night watching her son sleep. Warhol later made a lengthy film of a sleeping man.

Duane Michals: *242 Lexington Avenue,* 1958. © Duane Michals. Courtesy of the photographer and Pace/MacGill Gallery, New York.

Giallo would sit at the desk and spend a few hours each day tracing Warhol's drawings with india ink, then blotting the ink onto Strathmore paper by way of a taped hinge or by simply folding the paper in two to get a mirrored image. Warhol would often sit directly in

front of the television and do the same but with the work resting in his lap. The original sketches, which Warhol had traced the night before using the light box, were subsequently thrown out at the end of each day. The blotted-line drawings were presented to art directors at *Glamour*, *Harper's Bazaar,* and Bonwit Teller.

In the evening, Warhol and Giallo would go out to parties, often to the apartment of Nathan Gluck and his boyfriend, Clint Hamilton, where each guest, upon entering, was presented with a remarkably beautiful and intricately wrapped gift. Warhol often played Cupid, pairing boys together who may not have otherwise known each other. After Giallo left the job in 1956, Warhol employed Nathan Gluck as an assistant until the mid-sixties, paying him the minimum wage as he did with Giallo and later paid assistants.

By this time, Warhol had developed a reputation for delivering gifts to those who brought him work or exposure, and he regularly created books as a thank you. They were printed by Seymour Berlin, who also served as his trainer at the gym. Various friends including Ralph Thomas Ward (Corkie) and Charles Lisanby composed the text, and Julia Warhola would copy it in her distinctive, fanciful handwriting.

When the books came back from the printer, in limited editions of around one hundred, Warhol often hosted coloring parties, where a few acquaintances would arrive for an evening of food and drinks, and be asked to help with a project. By this time, Warhol had also rented the building's parlor floor, which Stephen Bruce and Calvin Holt of Serendipity outfitted for him, feeling he should have a proper bachelor pad.

Guests, usually six at a time, sat around a large round dining table and colored in the books using Dr. Martin's dyes while chatting away the evening. There was no right or wrong way to fill in the pages even after asking Warhol for direction. Each guest would be in charge of a color and would exchange

books after coloring in an object on a specific page. At the end of the night all the books were finished. Actor Tom Lacy recalls Mrs. Warhola's homemade potato latkes, as well as Warhol's indulging his guests with glasses of expensive brandy. Lacy was at first very careful not to color outside the lines of the printed images, but Warhol reprimanded him for being too careful.

Later, Warhol would call friends to come pick up a cat or two when Sam and Hester had reproduced. He told Giallo that Hester, the adult female, was once owned by Gloria Swanson; Giallo shot him a look, and Warhol smiled, allowing that it was okay to stretch the truth some times. Gillian Jagger dropped by the apartment to pick up a beautiful Siamese cat after Warhol told her Hester had started to kill her kittens. Jagger noticed there was suddenly a good deal of expensive furniture in the top-floor apartment, seemingly purchased from a department store like Macy's, but yet to be unwrapped. Jagger had the impression that friends suggested to Warhol that he needed to furnish the apartment and so he did, but with no intention at the time of actually *using* the furniture, remarkably like his habit of buying antiques in the eighties, then dumping them in a room, never to be unwrapped.

Eventually, Warhol had no more room for expansion. He had outgrown the apartment on lower Lexington and was in the market to move to his own house. When he heard that a building in the Hardenbergh/ Rhinelander Historic District uptown had opened up, he made plans to purchase it. He and his mother and the cats moved to the uptown residence in 1960. Within a decade, the row of apartment buildings downtown on Lexington would be torn down to build a high-rise apartment building.

57

Andy Warhol's Last Factory—RAZED

1984–1994

**22 East 33rd Street/158 Madison Avenue/
19 East 32nd Street**

An Art Deco electrical substation was transformed in the early eighties to become Andy Warhol's fourth and final Factory. This four-story building joined a portfolio of properties he owned by that time, including several acres in Colorado, secluded beachfront property in Montauk, Long Island, and five buildings in Manhattan, this being the largest.

The facility held the production offices of Andy Warhol's *Interview* magazine; a film/video department; a painting space nicknamed the Ballroom on the third floor with a skylight; an area to entertain clients; and copious amounts of storage for hundreds of paintings, time capsules, and acquisitions. Here, Warhol created a great number of works including a series of Rorschachs, the Endangered Animal prints, and a series of paintings of Michelangelo's *Last Supper*. Some of his last works were a series of self-portraits, later titled the *Fright Wig* series, one of which was the holy grail in Richard Polsky's book *I Bought Andy Warhol* (2003).

Warhol's society portrait commissions continued to grow at the new Factory on 33rd Street. Here, the clients would arrive to a welcoming lunch, before having their pictures taken. To the amazement of the guests, Warhol sometimes served the food and cleaned up afterwards.

Andy Warhol's MTV show *Andy Warhol's Fifteen Minutes* was also created here, as well as the books *Andy Warhol's Party Book* and *America*.

The T-shaped building, with addresses on three separate New York City streets, has since been razed.

vito Giallo

58
Chelsea Hotel
1960s, 1970s
222 West 23rd Street (Seventh Ave./Eighth Ave.)

Once the tallest building in Manhattan, the Chelsea
has had its fair share of renown, much of which is
connected to Warhol. *The Chelsea Girls*, Warhol's split-
screen saga detailing situations in various rooms in the
hotel, was partially filmed here. *Newsweek* hailed it as
The Illiad of the underground, elevating Warhol's repu-
tation as a prominent and noteworthy filmmaker.

Members of the Warhol crowd who have roomed
at the Chelsea include Nico, Brigid Berlin, and the model
Edie Sedgwick, who narrowly escaped from her burning
room (for the second time, see page 47) unlike her cat
named Smoke.

Other hotel guests have included photographer
Robert Mapplethorpe, singer/poets Patti Smith and Jim
Carroll, John Cale of the Velvet Underground, Betsey
Johnson, Viva, Bob Dylan, and Valerie Solanas, who
shot Andy Warhol.

The restaurant at the base of the Chelsea, El
Quijote (226 West 23rd Street), has been a mainstay at
the hotel as long as the oldest patrons can remember.
Loyal customers enjoy Spanish-style cuisine served in
abundant portions along with fresh seafood. Andy
Warhol and the members of the Factory dined here
often; the meals served to his actors and his crew were
always on his tab. The bar is famous in its own right,
serving everyone from Janis Joplin to the artist Julian
Schnabel, as well as folks from the neighborhood, who,
along with tourists, relax among the kitsch and adorn-
ments and enjoy one of the most inexpensive lobster
dinners in the city.

59
New York Antiques Fair and Flea Market aka The Annex
1960s, 1970s, 1980s
Sixth Avenue (24th St./26th St.)

Originally, the market appeared in 1965 at 25th Street and Sixth Avenue, ran from 1–7 PM, and cost 75 cents to enter. Eventually, hundreds of dealers gathered each Sunday from April until November, bringing out millions of items from stores, basements, and overloaded storage spaces. Andy Warhol was a regular. He could often be seen in the company of his friend Stuart Pivar, a fellow collector. The market has seen many changes over the years. New construction has pushed most of the open weekend flea market to Hell's Kitchen, and some into The Antiques Garage in an old parking garage at 112 West 25th Street.

60
Gramercy Arts Theatre
Early 1960s
138 East 27th Street (Lexington Ave./Third Ave.)
☆

In June 1963, Jonas Mekas designated this site, located in the Rose Hill section of Manhattan, the new home of independent cinema, presenting works at the Filmmakers' Showcase every Monday evening. Here, Andy Warhol's first films were seen by the public, including *Newsreel*, *Kiss*, and *Sleep*. By the following year, the Cinematheque, as it became known, had to move to another of its many homes over the years, after screenings of Jack Smith's pornographic *Flaming Creatures* led to a shutdown by nervous management. The film moved to the New Bowery Theater where it was confiscated a month later and Mekas was arrested.

This building has housed The Repertorio Español since 1972, presenting Spanish-language theater in the 140-seat auditorium.

Andy Ate Downtown

Il Cantinori

32 East 10th Street (University Pl./Broadway)
This Tuscan restaurant has been serving its stylish
patrons since 1983. Warhol dined here knowing that
gallerists Mary Boone and Leo Castelli, and the museum
curator Henry Geldzahler, would often be found chat-
ting away at a nearby table.

Ballato's Restaurant

55 East Houston Street (Mulberry St./Mott St.)
Warhol was known to frequent John Ballato's cozy
Italian eatery with associates and famous celebrities
and sometimes his furry companion, pet dog Archie.
Warhol kept Archie on his lap, hidden from view under
a cloth napkin.

Odeon

145 West Broadway (at Thomas St.)
Originally called Towers Cafeteria, Odeon was
transformed by the restaurateurs the McNally brothers,
into a Tribeca mainstay, keeping the 1930s elements
from the original venue. When it opened in the early
eighties, elite tribes immediately converged on this
hip, upscale restaurant, among them fashion editor
Anna Wintour, artists Ross Bleckner and Jean-Michel
Basquiat, designer Calvin Klein, and Andy Warhol
with entourage in tow.

61
Warhol's 2nd Factory
1968–1973
33 Union Square West (16th St./17th St.)

By December 1967, there were plans to move Warhol's
Factory to an office building on Union Square West. The
lease on the 47th Street space had been lost due to a
developer's plan to erect 1 Dag Hammerskjold Plaza
on the corner of Second Avenue and 47th Street. The
eleven-story Decker Building on Union Square was
designed by John Edelmann, an architect known to
have anarchist sympathies, for the Decker Piano Co.
The 1893 structure, created in a Moorish style, features
sunflowers, ogee arches, and arabesques on the façade.
The minaret on top was removed many years ago.

The new sixth-floor space was bright, painted
white in the front with a screening room painted dark
brown in the back, with hardwood floors and other wood
molding throughout. It was certainly nothing like the
old space, which had tired concrete floors, crumbling
silver walls, and dilapidated furniture. Nonetheless, the
new space was still called the Factory (and sometimes,
the White Factory). A stuffed Great Dane (which Warhol
hinted had belonged to Cecil B. DeMille—though the
staff could never match it to any photos of DeMille's
dogs) stood next to the entrance as their lone security
measure. The sixth floor has one of two front exterior
balconies.

Initially, a painting space wasn't required due to
Warhol's retirement from painting in May 1965; film
projects were now the focus of his business. He had
formed Andy Warhol Films, Inc., and with the help of
Paul Morrissey, began to create a business he hoped
might generate interest in Hollywood. The first project
was a western later named *Lonesome Cowboys*, filmed
in Old Tucson, Arizona, on a dude ranch where John
Wayne had made Hollywood westerns. One day the

shoot included a fake rape scene, catching the attention not only of the local police but eventually the FBI, who compiled evidence in order to find cause to arrest Warhol; but no action was ever taken.

When Warhol and his crew returned to New York in February 1968, the old Factory crowd had begun to frequent the new space at Union Square. By June, one of the Factory hangers-on, a writer and radical feminist named Valerie Solanas, was determined to increase awareness for her anti-men group, S.C.U.M. (Society for Cutting Up Men). She spoke on local radio to promote several of her books such as *Up From the Slime* and *A Young Girl's Primer on How to Attain to the Leisure Class*. She was also pushing a script, *Up Your Ass,* she hoped Warhol would turn into a film. Warhol had given her a part in a movie a year earlier titled *I, a Man*, so she could earn money instead of simply asking for handouts. She made little money otherwise. She tried to take Warhol's life by gunning him down on June 3 in the main room at the Factory, also wounding art critic Mario Amaya. Warhol was taken to Columbus Hospital on 19th Street and barely survived.

Paul Morrissey took it upon himself to continue filming new work, starting with *Flesh* starring Joe Dallesandro as a street hustler. Asked how Morrissey came to direct, Warhol said, "Well, it was whoever worked the camera. Then I guess I was in the hospital, and he worked the camera—so that's how it happened." Before long, Morrissey had directed several films, including *Trash*, *Women in Revolt*, and the cult films *Andy Warhol's Frankenstein* and *Andy Warhol's Dracula*.

In April 1970, Andy Warhol Films, Inc., purchased two buildings located, respectively, on Great Jones Street and the Bowery. Warhol had fully recovered and turned to other ventures such as creating a film journal to feature his films. With the help of John Wilcock, a co-founder of *The Village Voice*, as well as briefly tenured editors Malanga and Morrissey, *Inter/View* was born and

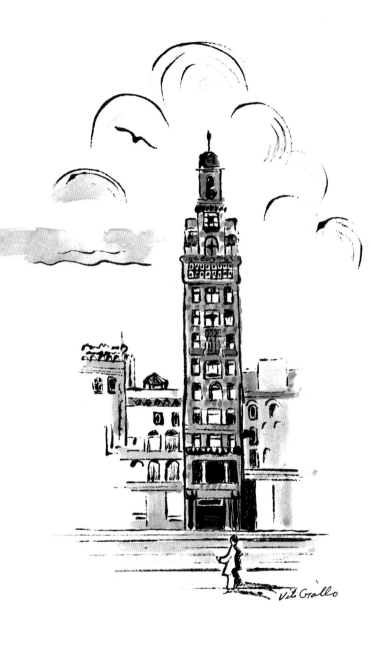

33 Union Sq. West

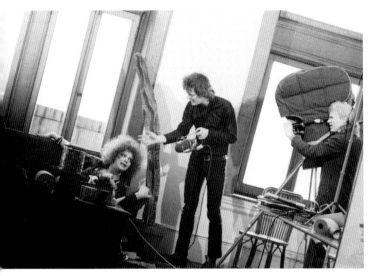

Gretchen Berg: from left, Jackie Curtis, Paul Morrissey, and Andy Warhol filming at the Union Square West Factory, circa 1972. © Gretchen Berg.

originally sold for 50 cents an issue. It quickly expanded from a film rag printed on newsprint to a large, bold, glossy, colorful fashion and film magazine praised for its candid interviews and striking covers by Richard Bernstein.

Even with everything going on, Warhol was not satisfied. He wanted new capital to pay for his new ventures, and turned once again to painting. He acquired space on the eighth floor of the Decker Building and began to create new works. He began his painting life anew by creating portraits on commission, the start of one of his signature projects, the *Society Portraits*. Later on, he created a series of paintings here based on a photograph of the Communist leader Mao Tse-tung, which were so big he had to move the biggest ones to the main sixth floor.

Warhol's paintings and work ethic would both shine again, and would revitalize the company while the films achieved only moderate success. Before long, the end of the lease on the second Factory prompted Andy Warhol's team to find a new work space and they

moved down the street in September 1974. The Decker
Building has since been turned into condominiums.

62
Columbus Hospital (Cabrini Medical Center)
1968
227 East 19th Street (Second Ave./Third Ave.)
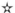

On June 3, 1968, a radical feminist and Factory hanger-
on named Valerie Solanas shot Andy Warhol. Warhol
was taken to Columbus Hospital, and pronounced clini-
cally dead. He was revived after doctors massaged his
heart and worked for hours, removing pieces of dam-
aged organs and cleaning the bullet paths made by
Solanas's gun. After a nearly two-month stay, Warhol
was released and ordered to wear a corset for the rest of
his life to keep his scarred chest from reopening. Richard
Avedon recorded the marks made by the stitches in a
well-known photo. Warhol announced to friends that
the surgery scars made him look like a Dior dress.

Candy Darling was later hospitalized here while
she received treatment for cancer and eventually died
here in 1974. In 1988, after the hospital became Cabrini
Medical Center, Jean-Michel Basquiat was brought here,
having overdosed on heroin. He was pronounced DOA
(dead on arrival). The hospital has now closed.

63
3rd Factory aka The Office
1974–1984
860 Broadway (17th St.)

The third floor of this building, once the offices of
S&H Green Stamps in the twenties, was the setting for
Warhol's third Factory from 1974–1984. Here, Andy
Warhol Enterprises, initially set up in 1957 for tax pur-
poses, took off. The new Union Square space was just

down the block from the former one and had a back elevator, an added level of security to prevent another Valerie Solanas–type incident from taking place. They had greatly increased their overhead and Warhol and his associates began working to get many projects off the ground.

One of the first was accidental: Warhol's *Time Capsules*. Warhol took standard packing boxes left over from the move from 33 Union Square a block away, and began to fill them with hundreds of items coming into the office each month. Once Warhol had filled a box, it would be sealed, dated, and packed away; currently the Warhol Museum in Pittsburgh houses the 600+ boxes. This procedure echoes the first Silver Factory, where Warhol and his assistants set up an assembly line to produce a series of wooden boxes painted to look like cardboard cartons.

Warhol created a studio in a back room, churning out work with the help of his assistants while handing off projects to his printing manager, Rupert Jasen Smith, and his team of printers and silkscreeners. A number of well-known series came about here including the *Skull Paintings*, whose shadow accidentally cast a baby's profile, the *Hammer and Sickle* series, *Shadows*, *Oxidation Paintings* (*Piss Paintings*), *Torsos*, *Dollar Signs*, and most prominent, the portraits of famous dignitaries, socialites, and loads of celebrities, later called the *Society Portraits*. The portraits were head-shots usually taken with a Polaroid camera (the Big Shot starting in 1971) and the images were then blown up to accommodate a canvas sized 40" by 40". In Warhol's vision, the celebrity images would one day become transformed into one gigantic exhibit and would all fit together neatly. And indeed, in 1979, Warhol put together an exhibition of fifty-six pairs of the portraits at the Whitney.

Interview also kept Warhol and his staff quite busy. The magazine, which started out as a floppy

movie journal on newsprint, had become a commercial success featuring artwork by Richard Bernstein and candid interviews with artists, musicians, and politicians, weaving fashion throughout the pages. The magazine continues more than forty years later.

Warhol's film partnership with director Paul Morrissey came to an end in 1974 after working together for nearly a decade. Warhol had had his eye on video as an important medium early on. He first worked with a video camera (a loan from the Norelco company) in the summer of 1965, and he later purchased a Sony Portapak in 1970. He continued to update to newer equipment and opted for broadcast-quality gear by the end of the seventies. His team, including producers Vincent Fremont and Michael Netter and director Don Munroe, began creating works with the state-of-the-art equipment and generated a series of shows titled *Andy Warhol's TV*.

At the end of 1984, the film and video operations were moved to a former Con Edison substation on Madison Avenue, leaving Warhol alone to paint in his studio. He reenergized his image by producing artwork with younger artists of the time, notably Keith Haring, Jean-Michel Basquiat, and Francesco Clemente. At the end of 1984, he would hand the lease of the third Factory over to designer Stephen Sprouse.

Books created here include *The Philosophy of Andy Warhol (From A to B and Back Again)* and *Andy Warhol's Exposures*.

64
Max's Kansas City
1965–early 1980s
213 Park Avenue South (17th St./18th St.)

Max's originally opened in December 1965 as an art bar and restaurant; patrons included Donald Judd, William Wegman, John Chamberlain, and Richard Serra, among others. Andy Warhol and his Factory denizens began frequenting the place shortly after it opened, and they quickly occupied tables in the back of the restaurant on a nightly basis. Warhol had an open tab and often could feed his entourage and actors by exchanging paintings for credit with owner Mickey Ruskin, before long, promising thousands of dollars worth of art as credit to pay for the sustenance of his Factory children. Ruskin had experience in the business after running several other bars and restaurants, including the Ninth Circle and the Tenth Street Coffeehouse.

Soon, the band Warhol promoted, The Velvet Underground, began performing at Max's along with other musical acts, and the audience came not only for the "Steak, Lobster, Chick Peas" (embossed in huge letters on the sign outside the building), but for the music. A line began to form each night and much like at Studio 54 later on, only certain people were allowed in. Max's closed briefly in 1974 and reopened in 1975, becoming home to punk and new wave bands including Devo, the New York Dolls, and Blondie. (Debbie Harry was a waitress here.) By November 1981, the doors at Max's closed for good. Today, a delicatessen operates on the ground floor.

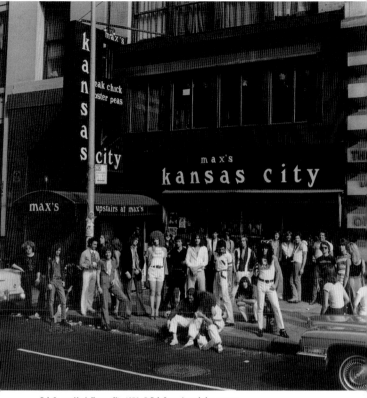

Bob Gruen: Max's Kansas City,1976. © Bob Gruen/www.bobgruen.com

65
Brownie's
late 1960s–1970s
21 East 16th Street (Fifth Ave./University Pl.)
☆

Samuel Brown's natural foods restaurant and store was
one of the longest-running vegetarian establishments
in New York history. Started in 1936, Brownie's became
a destination for health fanatics, vegetarians, Factory
associates, and Warhol after his shooting in 1968 when
his doctor told him to keep an eye on his diet. He
would later become an advocate for vegetarianism

though he remained a meat eater; he sneaked his
favorite foods and desserts whenever possible.

After leaving the Factory and before a night out,
Warhol would load up his bag here with TDK 90-minute
tapes, Kodak TX-36 b&w film, and Duracell Alkaline
AA batteries.

Danny Meyer's Union Square Café now occupies
the Brownie's address.

66
Balducci's
1970s, 1980s
424 Sixth Avenue (9th St./10th St.)

In the mid-seventies, Factory lunches were procured
from the gourmet Italian grocery store Balducci's, and
usually picked up by Brigid Berlin, who became a
Factory regular in the early sixties and a full-time
Factory employee shortly after Warhol moved to 860
Broadway. A typical order would consist of curried
chicken salad, string bean salad, pasta salad, sliced
tomatoes and broccoli in oil, and several loaves of bread.

Having struggled with her weight for many years,
Berlin was known to take amphetamines regularly; they
had been prescribed for her, at the insistence of her
parents, at an early age. But weight continued to be an
issue for her. When she returned from a Balducci's
lunch run, loaded down with numerous bundles, Warhol
might accuse her of forgetting something and tease her
about the whereabouts of the dessert, in a relationship
she described as like "Edith and Archie Bunker." (Berlin
quit taking amphetamines in 1974.)

Warhol and Berlin would typically call each other
nightly and each tape-record the conversation, as
Warhol did routinely with the art critic David Bourdon.
Berlin recorded just about all her phone conversations
with everyone. Tapes she made including information
about her mother, Honey Berlin, wife of Hearst corpora-

tion chairman Richard Berlin, were sold to Warhol and became the basis for the play *Pork*, which premiered at La MaMa, ETC on May 5, 1971.

67
Luchow's—RAZED
1960s, 1970s, 1980s
110–112 East 14th Street (Third Ave./Fourth Ave.)
"Through the doors of Luchow's pass all the famous people of the world" read a sign that was salvaged when the expansive German food hall moved from 14th Street to 1633 Broadway at 51st Street in 1982. The restaurant moved uptown but was never as successful after it left behind the century-old premises on 14th Street—its high-ceilinged theatricality, rococo light fixtures, a seemingly endless mahogany bar, and scores of darkened oil paintings in baroque frames that hung on the walls alongside vintage banquet photos of venison dinners capable of feeding a small army. Luchow's had big taxidermic heads overlooking the diners— bears, boars, and steer. Some of the seating was imported from the mess hall of a Bavarian penitentiary.

The restaurant changed hands at least a dozen times after opening in 1882. Despite often-gruff waiters and a Christmas tree displayed well past the holiday season, diners enjoyed copious portions of goose, lingonberries, schnitzel, and an array of decadent desserts.

Warhol, who dined at Luchow's on a regular basis, always brought along the *jungen* and *mädchen* (boys and girls) of his Factory staff so he could discuss would-be projects over dinner.

The former Luchow's building burned in 1994, and was razed the following year.

68
St. Mary's Catholic Church of the Byzantine Rite
246 East 15th Street (Second Ave.)—REBUILT
225 East 13th Street (Second Ave./Third Ave.) —RAZED
✴

Warhol and his mother Julia attended services at this Gothic church on a weekly basis until the church was torn down. Plans were filed in 1959 to build a new church, which was completed in 1963. Warhol had moved uptown, but he and his mother continued coming here until Julia was taken back to Pittsburgh in 1971.

Services were conducted according to the Byzantine Rite, sometimes referred to as the Rite of Constantinople. The Warholas had been members of St. John Chrysostom Byzantine Catholic Church in Pittsburgh. Andrew was baptized there when the family lived on Dawson Street in the Oakland section of the city and attended services several times a week. Warhol spent hours as a child gazing at the large gilded wall, or iconostasis, a screen filled with icons. Each icon was framed in a grid-like pattern much like Warhol's later panels of portraits.

69
The Open Stage—RAZED
1966
23 St. Mark's Place (Second Ave./Third Ave.)
In 1966, Warhol was promoting a new musical act, The Velvet Underground. After the success of the multimedia event at the 41st Street Theater called *Andy Warhol, Up-Tight*, the band was supposed to play at the opening of a new nightclub in Queens, but the deal soured. They had already rented equipment, so associates referred Warhol to a long mirrored room called the Open Stage at the Polish National Hall on St. Mark's, over the bar nicknamed the Dom. Originally advertised

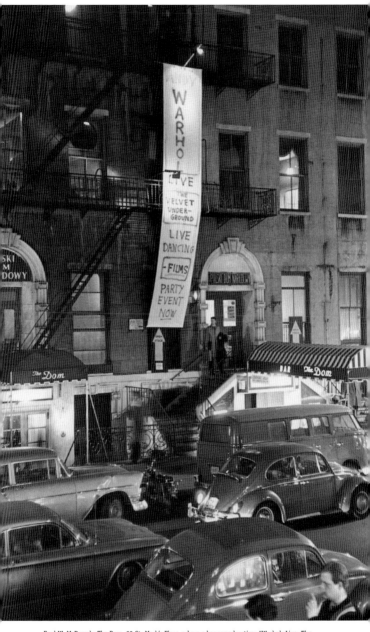

Fred W. McDarrah: The Dom, 23 St. Mark's Place, where a banner advertises "Warhol; Live; The Velvet Underground; Live Dancing; Films; Party Event Now," part of Andy Warhol's Exploding Plastic Inevitable series of staged, multimedia events held primarily in 1966 and 1967, New York, New York, March 31, 1966. © Fred W. McDarrah/Getty Images.

at the end of March 1966 as the Erupting Plastic Inevitable, the name soon changed to the Exploding Plastic Inevitable, or EPI, shows. The Velvet Underground and Nico were set back on a raised platform over which Warhol's films were screened while Factory regulars Gerard Malanga and Ingrid Superstar (and later, the actress Mary Woronov), danced in front of the band. Audiences peered through streaks of red light and strobe effects, as slides were projected onto the entire stage, leading one reviewer to say the event had "the air of a dancing party out of 'The Masque of the Red Death.' "

The EPI shows' success prompted a return to 23 St. Mark's, now renamed the Balloon Farm, in September. The run continued until the end of October; the shows moved to Steve Paul's The Scene at 301 West 46th Street in January.

In February 1967, the records show Warhol all over town with *The Chelsea Girls* at the York Cinema, the Velvets at the Gymnasium, and Nico (now out of the band) performing here at the New Mod-Dom, singing to the recorded sounds of The Velvet Underground while Warhol projected films over her and backup singers including Tim Buckley, Jackson Browne, and artist Jonathan Talbot.

The venue at 23 St. Mark's later became the Electric Circus but closed soon after a bomb exploded at the discotheque in March 1970, injuring seventeen patrons. The building was reconstructed in 2003 along with several neighboring buildings and has since become part of a mini-mall.

70

New Bowery Theater

1963

4 St. Mark's Place (Second Ave./Third Ave.)

☆

James Fenimore Cooper and his family lived in this townhouse sometime after it was built in 1831 and before 1834, when Alexander Hamilton's son bought it. By 1879, there was an office here selling cures for tapeworms; by the turn of the century, one could purchase early bromide photos and strings for stringed instruments. Cooper Union used the building as an alumni house in the 1930s. By the 1950s, an Off-Broadway theater named The Tempo had moved into the building, which later became home to multiple film venues.

In 1963, Jonas Mekas's weekly experimental film screenings left the Charles Theater at 193 Avenue B (at 12th St.) and subsequently took up residence in more than a dozen theaters throughout New York. Warhol, who was a regular at the Charles's screenings, began to show work through Mekas's Film-makers' Cinematheque; when their run of weekly screenings at the Gramercy Arts Theatre ended due to controversy over Jack Smith's *Flaming Creatures*, the series moved here.

Warhol premiered his film *Tarzan and Jane, Regained . . . Sort of* on February 18, 1964, at the New Bowery. Within a month, Mekas and three associates would spend a night in jail for showing films deemed obscene by the police—namely Jack Smith's *Flaming Creatures*. All of the equipment was seized including projectors, films, and a reel of Warhol's called *Newsreel*, which recorded the making of Jack Smith's *Normal Love*. The Cinematheque shut down here; the newly nicknamed Filmmakers' Supermarket had to operate by private rental out of 83 East Fourth Street, renting rather than projecting films.

In March 1965, the New Bowery became known as The Bridge and showcased happenings and Fluxus-

related work by Yoko Ono, John Cage, Robert Rauschenberg, and Al Hansen. By the 1970s, an upscale secondhand clothing store called Limbo had moved in, but gave way in the early eighties to Trash and Vaudeville, the legendary punk and goth garment megastore which outfitted Blondie and the Ramones, and still reigns over St. Mark's with a silver studded fist.

71
La MaMa ETC
1960s, 1970s
74A East 4th Street (Second Ave./Third Ave.)
✴

Ellen Stewart, or as thousands of playwrights have called her over the years, La MaMa, was originally a dress designer from New Orleans, Louisiana. "I can't write myself and I can't act, but I love the theater," she said. She opened the Experimental Theatre Club in 1961 in the basement at 321 East 9th Street, and soon the Café La MaMa began presenting works by artists including Tennessee Williams, Eugene O'Neill, and Harold Pinter. Stewart had just begun to carve out her niche in the theater world when the city cracked down on her space, trying to evict her several times, as the productions violated city use ordinances. In July 1963, Stewart reopened in a second floor loft at 82 Second Avenue, staying until November 1964.

With the fire department and city on her trail, she persisted and moved once again to the second floor at 122 Second Avenue. It was here that the theater troupe realized the full force of Stewart's vision. Plays written by Sam Sheppard, Lanford Wilson, and Leonard Melfi, and productions directed by Tom O'Horgan, were staged, among others. A touring troupe spent residencies in Paris and Copenhagen, while outposts sprung up in Bogotá, Colombia, and across the United States. Performances were held at this Second Avenue location

until the fall of 1968, when the Ford and Rockefeller Foundations granted La MaMa the money it needed to put a down payment on the building where it remains today. The striking 1873 structure on East 4th Street was originally called the Cinderella Society Building after a German institution dedicated to classical musicians, that was located here. During reconstruction of the building's ruined interior, the theater troupe performed out of a second floor space at 9 St. Mark's Place.

Many playwrights, musicians, and poets associated with Warhol had connections to La MaMa. Screenwriter Robert Heide's play *Why Tuesday Never Has a Blue Monday* premiered at La MaMa on August 10, 1966.

Jackie Curtis, who appeared in several of Warhol's films including *Flesh* and *Women in Revolt*, wrote *Vain Victory: The Vicissitudes of the Damned*, which premiered at La MaMa on May 26, 1971, starring Curtis, Ondine, Holly Woodlawn, Mario Montez, and Agosto Machado, and featuring music written by Lou Reed.

Warhol's play, *Pork*, based on the taped phone recordings between Brigid Berlin and Warhol regarding Berlin's family life, premiered May 5, 1971, in a production conceived and directed by Anthony J. Ingrassia with Warhol played by the actor Tony Zanetta. Harvey Fierstein (best known as Edna Turnblad in *Hairspray*) made his acting debut in the play; he went on to star in *Torch Song Trilogy* here, and, years later, in the film.

Ellen Stewart died in 2011.

72
Astor Place Playhouse
1965
434 Lafayette Street (E. 4th St./E. 8th St.)
✶

By the mid-sixties, Jonas Mekas of the Film-makers' Cinematheque had gone through at least four court cases, received several fines, and gone to jail fighting

film censorship in New York. Yet he forged on, screening experimental works at dozens of theaters including the New Charles Theater (193 Ave. B), City Hall Cinema (170 Nassau St.), Bleecker Street Cinema (144 Bleecker St.), The Village Gate (158 Bleecker St.), the New Yorker Theater (2409 Broadway), the lobby of Philharmonic Hall (Avery Fisher Hall) at Lincoln Center, the 41st Street Theater (125 West 41st St.), the New Bowery Theater (4 St. Mark's Pl.), and the Tivoli Theater (839 Eighth Ave.).

On June 5, 1965, the Cinematheque presented *Andy Warhol Shorties* which ran the next few weeks and included live evenings with Mario Montez, an underground drag favorite, and premieres of Warhol's *Vinyl* and *Poor Little Rich Girl*, starring Edie Sedgwick in her theatrical debut. In October, Warhol also screened *Temptations*, a Fire Island drama later called *My Hustler*. The Astor Place Theater is currently home to the Blue Man Group.

73
Andy Warhol Building
1970–1988
57 Great Jones Street (Lafayette St./Bowery)
☆

In April 1970, Andy Warhol Films, Inc., purchased a pair of buildings at 57 Great Jones St. and 342 Bowery as investments. Warhol rented out both buildings to kids he promoted or who were working for him. In the early eighties, among the artists who rented or owned lofts in the vicinity were Robert Mapplethorpe at 24 Bond Street, Chuck Close at 20 Bond Street, and Cy Twombly at 356 Bowery. In 1983, Warhol rented this two-story building to Jean-Michel Basquiat knowing that Bruno Bischofberger, Warhol's European (Swiss) dealer would cover the $4,000/month.

Built in the 1860s, the building had a colorful history, having caught fire in 1901 after a gas line ruptured

during a beer barrel delivery to the New Brighton Saloon and dance hall. This emporium became the headquarters by 1905 of the notorious gangleader Paul A. Kelly of the Five Points Gang. A policeman was killed here in a scuffle one night, leading to a raid and shootout in which Kelly was wounded.

Like Warhol's early firehouse rental, the building provided little insulation from the elements, and was in poor shape when Warhol bought it.

Basquiat created hundreds of paintings at this location, staying up for days at a time. He became one of the hottest young artists in New York, showing work at exclusive galleries, and earning thousands of dollars per painting. Warhol and Basquiat became close, collaborating on both paintings and sculptures. They often worked during the day, went out to clubs like Area (157 Hudson St.) in the evening, and dined at upscale restaurants all around town.

By late 1985, Basquiat's relationship with Warhol had become strained. The critics savaged their collaborations and Basquiat's drug use hit an all-time high. When Warhol suddenly died in 1987, Basquiat alienated himself from many art dealers and friends. On August 12, 1988, Basquiat accidentally overdosed on heroin in his second-floor bedroom. He was taken to Cabrini Medical Center, the same hospital where Warhol was taken when he was shot in 1968, and was pronounced DOA at age twenty-seven. Christie's auction house was quickly on site, taking inventory of the paintings, and advantage of the market, after Basquiat's death.

Prior to Basquiat, Walter Steding lived at 57 Great Jones, while working as a Warhol painting assistant and a recording artist for Warhol's Earhole Records.

Warhol's painting assistant, Jay Shriver, who came up with ideas for the *Camouflage* and *Rorschach* prints, lived at the other building at 342 Bowery.

74
Judson Memorial Church
1950s, 1960s
55 Washington Square South (Thompson St.)
✴

Designed by Stanford White in the late nineteenth century, this church became a cultural hub of Washington Square Park in the 1950s, embracing the community's diverse artistic character through poetry, dance, art, music, and film. The neighborhood was introduced to a wide variety of work including paintings by Claes Oldenberg, Jim Dine, and Robert Rauschenberg; Fluxus and other performances by John Cage and Yvonne Ranier; choreography by Freddy Herko, Lucinda Childs, and the Judson Dance Theater; poems by William Godden and Robert Hanlan; and films by Jack Smith. The Silver Factory's Billy Name, who lived nearby at 272 E. 7th Street, designed lighting for many performances here.

Freddy Herko, Lucinda Childs, Billy Name, and Jack Smith all appear in Warhol films. Freddy Herko committed suicide at age twenty-nine by leaping out of the fourth-floor window of his friend Johnny Dodd's apartment at 5 Cornelia Street.

75
Café Bizarre—RAZED
early 1960s
106 West 3rd Street (MacDougal St./Sullivan St.)
Andy Warhol met The Velvet Underground at this café in December 1965. The group had no current management and was not against having a well-known name like Andy Warhol attached to them to gain notoriety. Warhol felt at the time that the group, whose members included Lou Reed, John Cale, Sterling Morrison, and Maureen Tucker, needed an attractive front person. The actress Nico (Christa Paffgen), who appeared in Fellini's 1960 film *La Dolce Vita*, was introduced to the band

less than a month later as lead singer, much to the band's eventual resentment. Nico had recorded her first single, "I'm Not Sayin'" (by Gordon Lightfoot, with Jimmy Page on guitar), in 1965 and met Warhol in January 1966.

Warhol supported the band by finding them gigs, feeding them at various restaurants around town, and paying for studio time; he was effectively the group's manager. The band played across the country, building up a reputation in the Midwest and on the East Coast, but was largely rejected by the hippie audience on the West Coast. A year later and just before their first album appeared in March 1967 as a work by The Velvet Underground and Nico, the band ousted Nico, leaving her to perform by herself to a set of prerecorded Velvets songs, while the rest of the band played concerts around New York, starting with the Gymnasium shows. By the end of the year, the group ousted Warhol himself due to frustrations over their management, which included the late arrival of, and low sales from, their first album.

76
Caffé Reggio
1960s
119 MacDougal Street (W. 3rd St./Minetta Ln.)
✳

This café claims to have introduced the cappuccino to New York City. It was a regular haunt for Beat poets in the late fifties, and occasionally, members of Warhol's Factory. In the fall of 1968, Warhol visited here with his friend Robert Heide, the playwright, after recovering from his shooting by Valerie Solanas. To Heide, Warhol looked thin and angelic, almost as if he appeared in the form of an apparition. Warhol was down but not out; he would go on to reinvent himself and live for close to twenty more years. The café has appeared in many films, including *The Godfather: Part II* and *Shaft*.

77

Kettle of Fish

1960s

114 MacDougal Street (Bleecker St./Minetta Ln.)

☆

The Kettle of Fish became a major Village hangout for folksingers and Beat writers, and for Andy Warhol and his crowd. Edie Sedgwick met Bob Dylan and Bobby Neuwirth here and began to hang out with them, as she pulled away from Warhol. She refused to let him use a scene of her in *The Chelsea Girls* in 1966. Instead, she appeared in a Chaplinesque role in Neuwirth's *A Light Look*, a collection of comedies that also featured Dylan (and Salvador Dali), but plans for a movie co-starring Dylan and Sedgwick never came together. Dylan's "Just Like a Woman" may have been written about Edie.

Playwright Robert Heide tells the story that Edie cried at the bar here one night, tearing up about her lost relationship with Warhol. A little later, both Dylan and Warhol sat at the bar in close proximity and ordered drinks without saying a word to each other. Sedgwick walked out with Dylan.

After their exit, Warhol asked Robert Heide to show him the spot where the dancer Freddy Herko jumped out of the window at 5 Cornelia Street. While examining the pavement for the exact spot, Warhol turned to Heide and asked him when he thought Edie would commit suicide. Nonchalantly, Warhol said, "I hope she lets me know so we can film it."

Sedgwick, who was still primarily in the same social circles as Warhol, would be seen with him publicly one more time: a pink-wigged Edie and Warhol attended Tiger Morse's swimming pool fashion event in January 1967 at the Henry Hudson Health Club in the basement of the Henry Hudson Hotel (353 West 57th St.).

A newer Kettle of Fish has opened in the West Village.

78
Le Figaro Cafe
1960s

186 Bleecker Street (MacDougal St./Sullivan St.)

☆

Now closed, this café opened on the corner of
MacDougal Street in this building in 1957. Named for
the pages of the French newspaper *Le Figaro* that wall-
papered the interior, it was a favorite for folks who
could spend all afternoon reading a paper, drinking,
or playing several games of chess. Within a few years,
MacDougal Street became host to thousands of tourists
"looking for Greenwich Village." In the evenings, there
were school kids mixed with bikers, drunks, and trans-
vestites all dodging the hundreds of taxis that perpetu-
ally dropped off more onlookers.

Cafés littered the street, many with barkers trying
to pull in the crowds; they avoided Mafia shakedowns
and circumvented arcane city laws that prohibited loud
live music and dancing. In 1965, Le Figaro advertised a
teenage discotheque but managed to avoid receiving
police citations by installing seat belts on the chairs, so
that the kids "could dance sitting down." Warhol, who
already had several teenagers on his payroll, attended
Le Figaro's weekly event, keeping a watchful eye out
for new talent. In 1969, Le Figaro closed.

The café reopened in 1976 for thirty more suc-
cessful years, but closed for good in 2008. The window
awnings still display the faded words, "Le Figaro Cafe."

79
Garrick Theatre/Café Au Go Go—RAZED
1960s

152 Bleecker Street (Laguardia Pl./Thompson St.)

In the mid- to late fifties, the Village attracted many
poets and writers for the blues and jazz performances
held in the buildings around MacDougal, Third, and
Bleecker streets. Warhol began showing films at the

299-seat Garrick Theatre (formerly The Little Fox Theater, then The Nickelodeon) beginning with *Harlot* in January 1965. The Café Au Go Go opened as a 204-seat basement theater under the Garrick and became one of the hippest places for early rock events and stand-up comedy acts such as Lily Tomlin, Richard Pryor, George Carlin, and Lenny Bruce, who was arrested here in 1964 on obscenity charges. Also, "Silver City for Andy Warhol" happenings organized by Al Hansen (father of Warhol actress Bibbe Hansen, the mother of music artist Beck) were held here, as well as performances by Nam June Paik.

The Garrick Theatre showed a variety of movies including old black and white silent films. Andy Warhol first started screening his work through Jonas Mekas's Film-makers' Cinematheque and this theater was one of several that held the experimental film showings. Warhol films shown here included *My Hustler*, *Bikeboy*, *The Loves of Ondine*, *Flesh*, *Blue Movie*, *Lonesome Cowboys*, and *Harlot*. The latter featured Warhol's first female impersonator, Mario Montez, named after the 1940s Dominican Hollywood star known as "the Queen of Technicolor." In July 1968, the theater was renamed "The New Andy Warhol Garrick Theatre" due to the overwhelming number of tickets he sold here and to recognize Warhol's survival after his attempted assassination.

Other performers who appeared here included John Lee Hooker, Muddy Waters, Jimi Hendrix, and Jim Morrison.

80
Caffe Cino—CLOSED
1960s
31 Cornelia Street (W. 4th St./Bleecker St.)
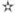

The birth of Off-Off Broadway is credited to Joe Cino and the performances held here at his café beginning in 1958. Early impromptu readings were soon turned into full-scale productions using scripts by Sam Sheppard, John Guare, and Doric Wilson. The tiny eight-foot-square stage erupted with performances that infatuated audiences for nearly ten years, with actors most notably including Harvey Keitel, Al Pacino, and Bernadette Peters. Robert Heide's *The Bed*, which ran here for several weeks, was filmed by Warhol and used in early versions of *The Chelsea Girls*. Work by the playwright and later Warhol screenwriter Ronald Tavel was also presented here, including *Vinyl* (later made into the film by Warhol). The shows' budgets were minimal. Most everyone worked for little if nothing and the lights came on when the sun went down. Early on, the main source of power came from an illegal electrical line run to the streetlight directly out front; when it came on, so did the stage lights.

The location is now the Italian restaurant Po, once owned by chef Mario Batali. A plaque on the building commemorates the Caffe Cino's contribution to Off-Off Broadway and memorializes the life of Joe Cino.

For specific topics, see the following stops:

Andy Warhol's Factories: 50, 57, 61, 63
Warhol Residences: 2, 16, 20, 23, 56
Galleries, Museums, and Exhibitions: 8, 9, 10, 11, 12, 13, 14, 17, 31, 41, 42, 46, 54
Film Premieres, Shootings, and Showings: 5, 14, 27, 29, 40, 43, 44, 46, 47, 51, 53, 58, 60, 70, 72, 79
The Velvet Underground: 19, 64, 69, 75

New York Warhol Art Exhibitions Cited in *Andy Warhol's New York City*

June 1952
15 Drawings Based on the Writings of Truman Capote
Hugo Gallery
26 East 55th Street
(with Irving Sherman)

April 1954
Group Show with Seven Others
Loft Gallery
302 East 45th Street

May 1954
Group Show with Two Others
Loft Gallery

October 1954
First Solo New York Show with drawings of dancer John Butler
Loft Gallery

February 1956
Drawings for a Boy Book
Bodley Gallery
223 East Sixtieth Street

April 1956
Recent Drawings—USA
MoMA
11 West 53rd Street

December 1956
Crazy Golden Slippers
Bodley Gallery

December 1957
Gold Pictures
Bodley Gallery

December 1959
Wild Raspberries, with Suzie Frankfurt
Bodley Gallery

November 1962
Pop Art
Stable Gallery
33 East 74th Street

March–June 1963
Six Painters and the Object
with Jim Dine, Jasper
Johns, Roy Lichtenstein,
Robert Rauschenberg, and
James Rosenquist
Guggenheim Museum
1071 Fifth Avenue

December 1963
Toys by Artists
Betty Parsons Gallery
24 West 57th Street

January 1964
*First International Girlie
Exhibit*
Pace Gallery
9 West 57th Street

April–May 1964
Brillo Boxes
Stable Gallery
33 East 74th Street

October 1964
The American Supermarket
Bianchini Gallery
16 East 78th Street

April 1965
*The Board of Governors
Collects*
Jewish Museum
1109 Fifth Avenue

May–June 1971
Andy Warhol
Whitney Museum of
American Art
945 Madison Avenue

June–July 1976
Portraits of Each Other,
with Jamie Wyeth
Coe Kerr Gallery
49 East 82nd Street

December 1977–January
1978
Warhol's Athletes
Coe Kerr Gallery
643 Park Avenue

November 1979–January
1980
Portraits of the Seventies
Whitney Museum of
American Art

September 1980–January
1981
*Ten Portraits of Jews of the
Twentieth Century*
Jewish Museum

February–May 1989
*Andy Warhol: a
Retrospective*
MoMA

March–August 2008
*Warhol's Jews: Ten
Portraits Reconsidered*
Jewish Museum

People Mentioned in
Andy Warhol's New York City

Richard Avedon Photographer who shot Warhol's scars after Warhol was shot by Valerie Solanas.

Jean-Michel Basquiat Painter and Warhol collaborator who rented Warhol's building on Great Jones Street as his studio.

Jack Wolfgang Beck Artist who provided his space for the Loft Gallery, where Warhol had his first group shows, with Beck and others, and his first solo show, all in 1954.

Brigid Berlin Warhol's long-time associate, both artistic collaborator and friend. Her father ran the Hearst corporation.

Seymour Berlin Printer of Warhol's books and his trainer at the gym.

Richard Bernstein Artist known for the iconic portrait covers of *Interview* magazine.

David Bourdon Art critic and Warhol phone pal.

Ann Buchanan Bohemian and former roommate of Allen Ginsberg and Neal Cassady, she sat for the "portrait of a girl who cried" in *Six of Andy Warhol's Most Beautiful Women*.

John Butler Warhol's first solo show consisted of drawings of this famed dancer and choreographer.

John Cale Multi-instrumentalist and composer for The Velvet Underground.

Lillie Mae (Nina) Faulk Persons Capote Truman's mother. Her society ways, Park Avenue address, and furs stood in marked contrast to Andy's own mother living with him in New York.

Truman Capote Novelist and symbol of success to a young Warhol. Like Warhol, he lived in New York with his mother.

Elliott Landy: Tiger Morse at a Random House publishing party.
© Elliott Landy/landyvision.com.

Leo Castelli Gallery owner who added Warhol to his
roster when the artist left Eleanor Ward at the Stable
Gallery.

Patricia Caulfield Photographer who sued Warhol
for appropriating her image of hibiscus flowers in
Modern Photography. In a settlement, she received
paintings and a percentage of proceeds from prints
of the Flowers series.

Phyllis Cerf Hostess, former Hollywood actress, wife
of Bennett Cerf of Random House, and later wife of
ex-mayor Robert Wagner.

Lucinda Childs Dancer, choreographer who appeared
in Warhol films.

Joe Cino Creator of Off Off Broadway theater at the
Caffe Cino.

Allan Hugh Clarke Artist who showed with Warhol in
his first two New York exhibitions.

Sheila Cole Writer and early Warhol apartment-mate.

Jackie Curtis Warhol actor and author of the play *Vain Victory: The Vicissitudes of the Damned*, which debuted at La MaMa.

Joe Dallesandro Actor and star of several Warhol films including *Flesh* and *Trash*.

Candy Darling (a.k.a. James Slattery) Warhol superstar.

Marie Desert Experimental filmmaker Marie Menken's pseudonym for the movie *Empire*.

Jim Dine Painter included with Warhol in the exhibition *Six Painters and the Object* at the Guggenheim in 1963.

Isabel Eberstadt Children's book writer who appeared in *Six of Andy Warhol's Most Beautiful Women*. Daughter of poet Ogden Nash.

Suzie Frankfurt Collaborated with Warhol on the exhibit and "cookbook," *Wild Raspberries*, in 1959.

Vincent Fremont Producer of Warhol TV shows and Factory principal.

Sid Geffen Ran the cinema space under Carnegie Hall and later owned the Bleecker Street Cinema with his wife, filmmaker Jackie Raynal.

Henry Geldzahler Art curator and longtime Warhol friend. When they met, Geldzahler was an assistant curator for twentieth-century American art at the Metropolitan. Helped Warhol secure the lease for the Silver Factory, the first of four, on East 47th Street.

Vito Giallo He managed the Loft Gallery and gave Warhol his first group and solo shows, then became Warhol's first paid assistant. Later, he would open antiques stores, where Warhol shopped regularly.

John Giorno Poet who starred in Warhol's *Sleep*.

Nathan Gluck Longtime Warhol assistant who played many roles: exhibiting with Warhol in the fifties and helping Warhol obtain and execute his commercial assignments including shoe drawings for I. Miller and illustrations for Bonwit Teller.

Paulette Goddard Hollywood screen idol who met Warhol at a charity gala in the seventies before they became an item around town.

Jon Gould Warhol's boyfriend in the early eighties.

Beverly Grant Actress who appeared in *Six of Andy Warhol's Most Beautiful Women.*

Halston Designer born Roy Frowick, known for chic seventies comfort. Neighbor of Warhol's in the East 60's; frequent host and companion at Studio 54.

Bibbe Hansen Artist, Warhol actress, daughter of artist Al Hansen, and mother of music artist Beck.

Robert Heide Playwright and Warhol screenwriter.

Freddie Herko Dancer and choreographer who committed suicide at the age of twenty-nine by dancing out of a window.

Baby Jane Holzer Model and "Girl of the Year 1964" who appeared in *Six of Andy Warhol's Most Beautiful Women.*

Frederick Hughes Longtime Warhol business associate, sometimes manager. He rented Warhol's house at 89th Street and Lexington Avenue when Warhol moved to 66th Street, and purchased it from the Warhol estate in 1988, the year after the artist's death.

Robert Indiana Painter who starred in Warhol's movie *Eat.*

Gillian Jagger Artist, Carnegie Tech alumnus, friend.

Jasper Johns Painter included with Warhol in the exhibition *Six Painters and the Object* at the Guggenheim in 1963.

Jed Johnson Interior designer and Warhol's longtime boyfriend.

Leo Kessler Carnegie Tech graduate and illustrator who passed his Lexington Avenue apartment to Warhol and his mother, Julia Warhola.

Sally Kirkland Actress who appeared in *Six of Andy Warhol's Most Beautiful Women*, and whose mother was the editor of *Life*, where she once featured Warhol's films.

Tom Lacy Actor who worked with Warhol in the art departments of both Bonwit Teller and I. Miller.

Roy Lichtenstein Painter included with Warhol in the exhibition *Six Painters and the Object* at the Guggenheim in 1963.

Charles Lisanby Production designer and early Warhol friend who traveled around the world with him in 1956.

Benjamin Liu Producer, society figure, and Warhol assistant in the seventies and eighties.

Bill McCarthy Warhol's boss at Bonwit Teller.

Gerard Malanga Poet, photographer, and longtime Warhol associate, first hired as twenty-year-old silk-screening assistant. Involved in numerous Warhol projects, including roles in many movies.

David Mann Gallerist instrumental in Warhol's career, first as an assistant at the Hugo Gallery, then at the Bodley Gallery, where he presented four early Warhol exhibits.

Jonas Mekas Experimental filmmaker and father of the underground film world, involved in making, presenting, and critiquing Warhol's films. Ran the Filmmakers' Cinematheque.

Mario Montez Underground drag favorite named after the 1940s Dominican Hollywood star known as "the Queen of Technicolor," actress, Warhol superstar.

Sterling Morrison Guitarist for The Velvet Underground.

Paul Morrissey Film director who collaborated with Warhol for a decade on numerous films.

Joan "Tiger" Morse Fashion designer and owner of the boutiques The Gilded Lily, A La Carte, Kaleidoscope, Teeny Weeny, and Tiger's Toys. She sold Warhol drawings in her shops.

Don Munroe Director of Warhol's TV shows.

Billy Name (Billy Linich) Photographer and longtime Warhol assistant who created the interior of the Silver Factory.

Ivy Nicholson Model who appeared in *Six of Andy Warhol's Most Beautiful Women*.

Nico Actress and singer (Christa Paffgen). Warhol convinced The Velvet Underground they needed her as a frontperson.

Ondine (Robert Olivo) Warhol superstar who played the role, among others, of Pope Ondine in *The Chelsea Girls*.

John Palmer Cameraman and director who had the idea to make *Empire*, Warhol's eight-hour portrait of the Empire State Building. Married to Ivy Nicholson.

Betty Parsons Gallery owner who showed *Toys by Artists* in 1963, including Warhol and thirty-three others.

Lester Persky Film producer and ad man who claimed to have discovered Edie Sedgwick. Introduced Warhol and Edie at a party at his house.

Stuart Pivar Friend who often shopped at flea markets and antique stores with Andy.

Richard Polsky Art collector and dealer who wrote the 2003 book *I Bought Andy Warhol*.

Edward Rager Artist who showed with Warhol in his first two New York exhibitions.

Robert Rauschenberg Painter included with Warhol in the exhibition *Six Painters and the Object* at the Guggenheim in 1963.

Lou Reed Singer/guitarist/songwriter for The Velvet Underground.

James Rosenquist Painter included with Warhol in the exhibition *Six Painters and the Object* at the Guggenheim in 1963.

Steve Rubell Owner/partner of Studio 54.

Mickey Ruskin Owner of Max's Kansas City, and recipient of Warhol art for Factory meals, drinks.

Ian Schrager Owner/partner of Studio 54.

Edie Sedgwick Model, actress, Warhol superstar.

Jay Shriver Warhol painting assistant who came up with the ideas for the *Camouflage* and *Rorschach* prints.

Jack Smith Artist and filmmaker whose pornographic *Flaming Creatures* provoked the ousting of Jonas Mekas's Film-makers' Cinematheque from multiple locations.

Rupert Jasen Smith Warhol's later printing manager.

Valerie Solanas Radical feminist who shot Andy Warhol at the Second Factory after appearing in his films.

Walter Steding Musician, artist, and Warhol assistant and musical artist on Warhol's Earhole Records.

Ellen Stewart Creator of La MaMa, ETC.

Ingrid Superstar Warhol associate, who danced with The Velvet Underground at the Exploding Plastic Inevitable shows at The Open Stage.

Ronald Tavel Playwright and Warhol screenwriter.

Maureen Tucker Drummer for The Velvet Underground.

Ultra Violet Artist, studio assistant and pupil of Salvador Dali, and Warhol superstar.

Viva Warhol superstar, movie star.

Diana Vreeland *Vogue* editor who claimed to have discovered Edie Sedgwick.

Corkie (Ralph Thomas Ward) Friend who wrote text for and colored early Warhol books.

Eleanor Ward Gallery owner who gave Warhol important shows during his Pop Art phase; he abandoned her for Castelli.

Julia Warhola Andy's mother and roommate.

Richard Weisman Art collector who commissioned the series *Warhol's Athletes*, shown at the Coe Kerr Gallery in 1978.

John Wilcock Writer and cofounder of *The Village Voice* who helped Warhol start *Interview*.

Jacques B. Willaumez Artist included in Warhol's first group show at the Loft Gallery.

Alfred Carlton Willers (Carl) Warhol's boyfriend who worked at the New York Public Library and provided the artist with a supply of photographs to trace for his blotted-line drawings.

Holly Woodlawn Actress and Warhol superstar.

Mary Woronov Actress who danced with The Velvet Underground at the Exploding Plastic Inevitable shows at The Open Stage.

Jamie Wyeth Painter. He and Warhol exhibited *Portraits of Each Other* at the Coe Kerr Gallery in 1976.

Paul Young Owner of hip boutique Paraphernalia, where Warhol helped stage a "happening" in 1965.

Introduction

"I like old things . . ." Andy Warhol, interview by Claire Demers, *Christopher Street* (September 1977), excepted in *I'll Be Your Mirror; the Selected Andy Warhol Interviews: 1962–1987,* ed. Kenneth Goldsmith, Reva Wolf, and Wayne Koestenbaum (New York: Carroll & Graf, 2004), 266.

1

he waited on Julie Andrews... Author phone interview with Gillian Jagger, November 5, 2009.

tea dates... Author phone interview with Gillian Jagger, November 5, 2009.

2

"I started when I was printing money..." Andy Warhol, interview by Glenn O'Brien, *High Times*, No. 24 (August 1977), excepted in *I'll Be Your Mirror; the Selected Andy Warhol Interviews: 1962–1987,* ed. Kenneth Goldsmith, Reva Wolf, and Wayne Koestenbaum (New York: Carroll & Graf, 2004), 242.

called up former assistant Vito Giallo... Author interview with Vito Giallo, May 15, 2009.

3

Sally Kirkland recalled seeing Warhol and his mother visiting church here... Author interview with Sally Kirkland, June 10, 2009.

15

Details from author interview with Vito Giallo, May 15, 2009.

17

The night of Ward's death... Author interview with Vito Giallo, May 15, 2009.

18

"a neighborhood restaurant with a varied menu..." Joan Kron, "Andy's Automat; No Campbell's on the Menu at Andy Warhol's Automat," *New York Times* (May 12, 1977), 49.

"I really like to eat alone..." Andy Warhol, *The Philosophy of Andy Warhol: from A to B and Back Again* (New York: Harcourt Brace Jovanovich, 1975), 160.

24

"I just sneak in at funny hours..." Andy Warhol, interview by Glenn O'Brien, *High Times*, No. 24 (August 1977), excepted in *I'll Be Your Mirror; the Selected Andy Warhol Interviews: 1962–1987,* ed. Kenneth Goldsmith, Reva Wolf, and Wayne Koestenbaum (New York: Carroll & Graf, 2004), 258.

stopped in a few times each week. . . . Author interview with Benjamin Liu, August 11, 2010.

25

a specific destination in mind: the statue of Balto, Andy Warhol: Private and Public in 151 Photographs, ed. Reva Wolf (New Paltz, N.Y.: The Samuel Dorsky Museum of Art, State University of New York at New Paltz, 2010), 62–67.

26

"A world of its own, inward looking and secretive..." Paul Rudolph, *The Architecture of Paul Rudolph* (New York: Praeger, 1970), 80.

28

"a country store with mostly old American things" "Fresh Flowers Are Sold from Gay Sidewalk Cart," *New York Times* (Sept 23, 1961), 11.

"I can't sew, drape, or cut a pattern..." "Joan (Tiger) Morse Is Dead," *New York Times* (April 25, 1972), 46.

"I'm a swan in a world of ducks." Bernadette Carey, "Tiger Morse: 'I'm a Swan in a World of Ducks'," *New York Times* (June 16, 1967), FS47.

"A lot of people have called me a witch..." Judy Klemesrud, "To Hear the Fashion Crowd Tell It, It's Written in the Stars," *New York Times* (May 2, 1967), 50.

"queer and fantastic quiddities" Barney Lefferts, "Who Collects What and Why," *New York Times* (Feb 21, 1960), SM19.

"They're afraid of what's happening..." Bernadette Carey, "Tiger Morse: 'I'm a Swan in a World of Ducks'," *New York Times* (June 16, 1967), p. FS47.

"They think I'm salvation." Eugenia Sheppard, "The Current Is on Again," *Hartford Courant* (October 20, 1964), 17.

"I have a hangup on sunglasses." Eleanor Nangle, Tiger Morse spread, *Chicago Tribune* (January 31, 1966), B2.

(She owned eighty pairs.) Eugenia Sheppard, "Pawing Through the Racks," *Hartford Courant* (May 22, 1962), 15.

"Isn't it wild?" Eleanor Nangle, *Chicago Tribune* (January 31, 1966), B2.

37
he ran into Salvador Dali's wife, Gala Andy Warhol with Bob Colacello, *Andy Warhol's Exposures* (New York: Grosset & Dunlap, 1979), 179.

38
Bonwit details from author interview with Bill McCarthy, March 26, 2009.

39
When they stepped into the elevator... Author interview with Tom Lacy, March 26, 2009.

41
"whole pop art problem." John Canaday, "Art: From Clean Fun to Plain Smut: Girlie Exhibit," *New York Times* (January 7, 1964), 31.

42
"suggests neither a game nor a philosophical question" John Canaday, "Toys by Artists Are Good Art and Good Toys," *New York Times* (December 22, 1963), X14.

46
"severely limited gallery and storage space." Alfred H. Barr, Jr., Director of the Museum Collections, MoMA, Letter to Andy Warhol dated October 18, 1956. Warhol Museum, Pittsburgh.

47
"The Empire State Building is a star!" Jonas Mekas, "Movie Journal," *Village Voice* (July 30, 1964), 13.

"Always leave them wanting less." Andy Warhol and Pat Hackett, *POPism: the Warhol Sixties* (Orlando: Harcourt, 2006), 193.

54
Details from author interview with Vito Giallo, May 15, 2009.

55
"The teachers liked me..." Andy Warhol, interview by Glenn O'Brien, *High Times*, No. 24 (August 1977), excepted in *I'll Be Your Mirror; the Selected Andy Warhol Interviews: 1962–1987*, ed. Kenneth Goldsmith, Reva Wolf, and Wayne Koestenbaum (New York: Carroll & Graf, 2004), 234.

56

*Teachers were known to regularly warn the students...*Author phone interview with Gillian Jagger, November 5, 2009.

Giallo recalls coming to the Lexington Avenue apartment... Author interview with Vito Giallo, May 15, 2009.

Warhol often hosted coloring parties... Author interview with Tom Lacy, March 26, 2009.

Gillian Jagger dropped by the apartment... Details from author phone interview with Gillian Jagger, November 5, 2009.

57

Warhol would sometimes be found. . . Author interview with Vito Giallo, May 15, 2009.

61

"Well, it was whoever worked the camera . . ." Andy Warhol, interview by Glenn O'Brien, *High Times*, No. 24 (August 1977), excepted in *I'll Be Your Mirror; the Selected Andy Warhol Interviews: 1962–1987,* ed. Kenneth Goldsmith, Reva Wolf, and Wayne Koestenbaum (New York: Carroll & Graf, 2004), 246.

67

A conversation with Brigid Berlin and Vincent Fremont, presented at the Brooklyn Museum, July 16, 2010.

69

"the air of a dancing party out of 'The Masque of the Red Death.'" Sally Kempton, "Notebook for Night Owls," *Village Voice* (April 14, 1966), 18.

71

"I can't write myself and I can't act..." Richard F. Shepard, "Coffeehouse Theaters Join to Present New Play," *New York Times* (August 8, 1964), Saturday section, 11.

76

Warhol visited here with his friend Robert Heide... Author interview with Robert Heide, June 10, 2009.

77

Edie Sedgwick met Bob Dylan and Bobby Neuwirth here... Jean Stein, *Edie: American Girl* (New York: Grove Press, 1994), 166.

Neuwirth's A Light Look... See advertisement for Film-makers' Cinematheque in the *Village Voice* (December 29, 1966), 20.

plans for a movie co-starring Dylan and Sedgwick never came together... Jean Stein, *Edie: American Girl* (New York: Grove Press, 1994), 285.

Dylan's "Just Like a Woman"... Clinton Heylin, *Bob Dylan: Behind the Shades Revisited* (New York: William Morrow, 2001), 232.

Playwright Robert Heide tells the story... Victor Bockris, *Warhol: the Biography* (New York: Da Capo Press, 2003), 235–6.

pink-wigged . . . "Scenes," *Village Voice* (January 12, 1967), 14.

78

"could dance sitting down." J.R. Goddard, "Sit-Down Disc [sic]: Fasten Your Seat Belts & Dance," *Village Voice* (November 18, 1965), 1.

80

Details from author interview with Robert Heide, June 10, 2009.

Author Interviews for *Andy Warhol's New York City*, in person unless otherwise indicated.

Gretchen Berg: May 21, 2009

Dorothy Blau: phone interview, November 6, 2009

Sheila Cole-Nilva: October 28, 2009; phone interview, July 23, 2009

Joseph Freeman: July 1, 2010

Vincent Fremont: phone interview, August 30, 2010

Vito Giallo: May 15, 2009; October 28, 2009

Robert Heide and Sally Kirkland: June 10, 2009

Gillian Jagger: phone interview, November 5, 2009

Tom Lacy and Bill McCarthy: March 26, 2009

Benjamin Liu: August 11, 2010

Duane Michals: December 8, 2009

Jeremiah Newton: May 19, 2009

Walter Steding: June 10, 2010

Anna Mae Wallowitch: phone interview, November 18, 2009

Jane Wilson and John Gruen: phone interview, November 18, 2009

Acknowledgments

Many wonderful people have embraced the idea of a New York City guidebook surrounding the life of Andy Warhol. I'd like to thank those who provided support and encouragement, which begins with my parents Cheryl and Daryl Kiedrowski, my brother Matthew, my sister Laura Yelon and her husband Josh.

The research process, which included interviewing people from Warhol's past, was an absolute joy. Many of those who sat with me or were kept on the phone for hours, have now become part of my own extended family. I'd like to thank everyone who made this project possible including:

Joe Warfield, Tom Lacy, Duane Michals, Robert Heide, John Gilman, Gretchen Berg, Gillian Jagger, Sheila Cole-Nilva, Vincent Fremont, Sally Kirkland, Ben House, Anna Mae Wallowitch, Paul Wallowitch, David McCabe, Jane Wilson and John Gruen, Bill McCarthy, Steven Bruce and Joe Calderone of Serendipity 3, Benjamin Liu, Gloria Fiero and Jim Dorman, Patrick S. Smith, Ed Chlanda at SOKOL New York, Walter Steding, Joseph Freeman, Jeremiah Newton, Dorothy Blau, and Tara Key.

I would like to thank Reva Wolf for her support and wish to credit Kathryn Cappillino for having identified the sculpture of Balto, in her essay in the exhibition catalogue *Andy Warhol: Private and Public in 151 Photographs*. Special mention goes out to my friend, Vito Giallo, for his exceptional works, his generosity, and his eternal patience. Gary Comenas of www.warholstars.org should be applauded. He has been an early influence, a dedicated curator and advocate for truth in all things Andy Warhol.

Unending mentions go out to my editor, Tim Harris. He has given this book the utmost attention, diligence, and supreme care, which is evident in each and every entry. I thank you, along with my publisher, Angela Hederman.

I would also like to thank the following for their cooperation: The New York City Public Library, The New York City Historical Society, Greg Burchard at the Andy Warhol Museum, and Michael Hermann and the folks at The Andy Warhol Foundation for the Visual Arts. Also thanks to the folks at the research library at MoMA.

About the Author

Thomas Kiedrowski is an independent scholar who received his B.F.A. in Film from the University of Wisconsin-Milwaukee. He lives in New York and leads tours to Warhol sites in New York City.

About the Artist

The original drawings in *Andy Warhol's New York City* were made specially for the book by the artist Vito Giallo, using the same blotted line technique* that he used when he was a studio assistant of Warhol's. Giallo later owned the antique store where Warhol bought many of the items that were posthumously auctioned at Sotheby's.

About the Type

The text is set in ITC Officina serif book designed by Erik Spiekermann; the display, Ziggurat Black, was designed by Hoefler & Frere-Jones.

*A blotted-ink drawing is made by first folding in half a piece of Strathmore or other similar high-quality paper. It is then unfolded, and on one half, an original drawing or tracing of a drawing is made. That drawing is then inked over bit by bit with India ink and after each inking quickly blotted onto the opposite half of the paper using the fold as a hinge. When the entire pencil drawing has been fully inked and blotted, a mirror image will have been created on the opposite half of the paper. The two halves are then separated at the fold, and the original inked-over image is discarded.

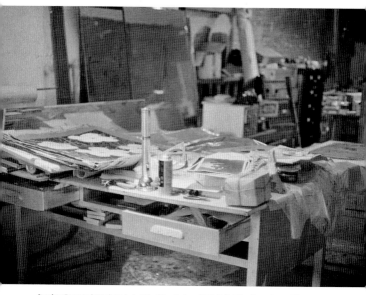

Gretchen Berg: Andy Warhol's desk at the Silver Factory, 1966. © Gretchen Berg. © 2011 The Andy Warhol Foundation for the Visual Arts, Inc./ Artists Rights Society (ARS), New York.